T0130784

the pop classics series

ain't no place for a hero.

borderlands

kaitlin tremblay

ecwpress

Published by ECW Press
665 Gerrard Street East
Toronto, Ontario, Canada M4M 1Y2
416-694-3348 / info@ecwpress.com

Editors for the press:
Jennifer Knoch and Crissy Calhoun
Cover and text design: David Gee
Series proofreader: Avril McMeekin

Library and Archives Canada
Cataloguing in Publication

Tremblay, Kaitlin, author
Ain't no place for a hero :
Borderlands / Kaitlin Tremblay.

(Pop classic series ; 8)
Issued in print and electronic formats.
ISBN 978-1-77041-364-1 (softcover)
Also issued as: 978-1-77305-076-8 (PDF)
978-1-77305-077-5 (ePUB)

1. Borderlands (Computer file). I. Title.
II. Series: Pop classic series ; 8

GV1469.25.B67 2017 793.93'2
C2017-902398-5 C2019-902977-0

Printing: Webcom 5 4 3 2 1
PRINTED AND BOUND IN CANADA

The publication of Ain't No Place for a Hero has been generously supported by the Government
of Canada through the Canada Book Fund. Ce livre est financé en partie par le gouvernement
du Canada. We also acknowledge the contribution of the Government of Ontario through the
Ontario Book Publishing Tax Credit and the Ontario Media Development Corporation.

For my mom,
my original co-op partner and best friend,
who always supports my weird and impractical decisions

Contents

Introduction: No Rest for the Wicked

I finished my master's, in English and film, when I was 23. And I was burned out in a way I had never experienced before, after ten months of unrelenting class work; detailing, researching, and writing a major research paper in lieu of a full thesis (because of said class work); teaching multiple classes as a teaching assistant; being the editor on the school newsletter; and starting out as a freelance editor, performing copy edits and substantive edits on various full-length manuscripts.

Like I said, I was burned out.

When I finished my master's, I couldn't look at a book. It sounds silly now, but opening a book and seeing how much there was left to read made me start panicking. I was used to reading for work, and the unread pages represented hours and hours of *more* work I still had to do. I needed to chill out, and my old reliable habit of disappearing into books and becoming consumed by their stories wasn't working anymore.

This is when, after almost ten years' absence, I got back into seriously playing video games.

Video games became a no-strings-attached way for me to enjoy storytelling again, while I let myself rest and recover from the intensive mental workout I had put myself through. Video games didn't offer me mindless entertainment: they offered me a whole new world of stories and storytelling to explore. They satisfied my need to engage with characters, narrative arcs, and imagery that I wasn't able to do with books — not yet, anyway. And they forced me to engage in a new way. It wasn't possible to be a passive consumer. Not that reading or watching films are wholly passive (readers and viewers are engaging, working to decode and bind meanings and images constantly). But with video games, I could control my player character's movements and development to become part of the world in a way I couldn't with any other medium.

The first Borderlands (which for clarity, I will refer to as *Borderlands 1* from here on out) was my re-entry into major games. Developed by Gearbox Software and released in 2009, *Borderlands 1* was a huge success, selling more than 4.5 million copies and receiving high review scores across the board from many major gaming websites. You're introduced to Pandora, the world in which Borderlands takes place, to the soundtrack of Cage the Elephant's "Ain't No Rest for the Wicked." Pandora is, quite simply, a hellhole — overrun by all means of murderous folk (bandits, assassins, and mercenaries), as well as aggressive monsters (my favorite enemies are skags, mutated-looking dogs that screech at you with a full mouth of dripping teeth to reveal a reptilian tongue). *Borderlands 1* begins with a group of bandits hitting a skag with their car and then

continuing on to their gory glory, or whatever it is bandits do in Pandora (often murder and cannibalism, referred to as "pizza parties"). This game was going to be sick. (And I mean sick as in disgusting, not in the way that used to be cool and hip but is probably totally not cool and hip now.)

But as "No Rest for the Wicked" played, I suspected it was going to be more than just a mindless murderous romp like so many other first-person shooter games.

From the very beginning, Borderlands wasn't about fitting neatly into its genre. In a first-person shooter (FPS), all you see is the gun you are holding and the enemies and landscape before you, and your main goal is to shoot as many enemies as possible. But Borderlands became fondly referred to as a "role-playing shooter" because it assumed many of the same features of traditional role-playing games (RPG). As in an RPG, in Borderlands, as you level up, you can build your character's proficiency in numerous ways, making your version of your character potentially very different from someone else's version of that same character. For a game that really wants you to play with your friends, being able to differentiate your character goes a long way. My favorite character to play is Salvador in *Borderlands 2*, but my Salvador build focused heavily on health regen and increasing my rate of fire, while a friend's focused on absorbing ammo and becoming stronger and more offensive: two entirely different ways to play the exact same character.

Borderlands is so adept at blending its two genres that it has spurred articles about Borderlands as a gateway for players

who prefer either RPGs or FPSs to explore the other genre. As Chris Kohler writes in *Wired*, this gateway comes in the form of spending skill points to customize the player character to your individual playing style: "*Borderlands* has thus been made more accessible for shooter beginners — not by dumbing the game down, but by actually increasing the complexity of the system in a way that lets nerds use their special nerd power of math to succeed."[1] Use math to understand how to spend your skill points to make your character as strong as you can in your chosen style, and voila, shooters are opened up to a whole new audience. It's not like Doom (1993 onwards) or Halo (2001 onwards), where players need to understand each gun's unique strengths and weaknesses; instead, players can build their characters to suit how they want to play, adding in regen, explosions, or defense where necessary. For Kohler, blending in RPG elements makes *Borderlands* more open to people who don't necessarily succeed at shooters but understand the basic mechanics that motivate RPGs. The game is open to a wider audience and more fun to play with friends, regardless of their FPS abilities.

Blending RPG elements into other genres wasn't an innovation when Gearbox released *Borderlands 1*. Many successful games were already blending genres, incorporating RPG elements into first-person shooters or third-person shooters (games where the player's character is visible on-screen, with the camera typically positioned over the shoulder of the character, or slightly above). *Fallout 3* (2008), Mass Effect (2007 onwards), Deus Ex (2000 onwards), and *Parasite Eve* (1998) all

blend RPG elements with shooters. But *Borderlands 1* did it with such irreverence that it felt blasphemous. It wasn't trying to be the best shooter of all time: it was trying to be the most *ridiculous* shooter of all time. The game mocked the seriousness of its genre, opening up FPSs to meaningful and subversive critique. By no longer holding its mechanics and tropes sacred, it could talk about the way this genre has tended to exclude women and people of color, the way it breeds toxic masculinity, and the way video games can challenge all of this by first acknowledging it and then making a more welcoming gaming environment (even on a death trap of a planet like Pandora).

Borderlands 2, released in 2012, took all that even further. Its announcement boasted "87 bazillion guns just got bazillionder," and went on to say the game would have 870 gajillion more guns and 96.5% more wub-wub. Yes. Wub-wub as in dubstep. *Borderlands 1* features a dancing robot named Claptrap. *Borderlands 2* was promising players a lot more of Claptrap dancing, even if nobody wanted this (and as Claptrap is one of the most eye-roll-worthy characters in the entire franchise, with his high-pitched voice and constant attention-seeking, *nobody* wanted more Claptrap dancing — except for a select handful of us who appreciate the finer things in life).

If *Borderlands 1* wanted to be funny and inappropriate and crass, *Borderlands 2* turned the notch up on all of these things from ten to 11,000. One of the official teaser trailers for *Borderlands 2* featured the four new Vault Hunters massacring monstrous animals on Pandora, all set to the tune of "The Lion Sleeps Tonight." It introduced players to the character

Torgue, a Macho Man–inspired arms manufacturer who loves guitar riffs and explosions and becomes personally offended when characters don't want to use guns that cause explosions.

Borderlands 2's entry onto the gaming scene was an explosion Torgue would be proud of. It became one of the best-selling games of 2012 (having sold more than 13 million, it was also Gearbox's bestselling title), was nominated for numerous awards, and brought more critical attention to Borderlands as a whole. And there was much more Borderlands to come: in 2014, Gearbox and the Australian division of their publisher, 2K Games, released *Borderlands: The Pre-Sequel*, and a mere month later, the spin-off point-and-click episodic game *Tales from the Borderlands* was released by Telltale Games in collaboration with Gearbox. In between all of this, there were comics published by IDW and written by Mikey Neumann, the writer of *Borderlands 1* and the chief creative "champion" at Gearbox, and novelizations published by Gallery Books. Everybody wanted more Borderlands. And still does. In April 2016, *Borderlands 3* was announced, with the art and tech used in the game being shown off at the Game Developers Conference in March 2017.

I loved Borderlands when all it was was shooting skags, killing bandits to take their money, buying even cooler shotguns, and discovering all the little ways this alien world peeked out from beneath the veil that tried to shroud it in normalcy. I loved Borderlands when it was dumb jokes about testicles and how badly enemies were going to hurt you and when it was about seeking retribution for a town terrorized by bandits.

But Borderlands became so much more to me when, with *Borderlands 2*, I got to see parts of myself in the game. I got to see an overweight woman character be unapologetically sexy. I got to see a bisexual woman not be ridiculed for being bi. When I got back into games, Borderlands helped me re-engage with storytelling when I was otherwise burned out. But Borderlands also helped me see parts of myself that I was struggling with identifying and accepting. Being able to connect so strongly with these characters helped me connect with pieces of myself that I didn't know how to fully express. I mean, games aren't the sole reason I was able to do this, but being able to pick up a game and see these parts of myself — and not be made to feel like they were jokes or undesirable — helped a lot.

And while there is still so much room to grow, especially in terms of representation of people of color and people with disabilities, Borderlands has made marginalized people feel welcomed in video games. In a climate where talking about inclusivity and diversity in video games is met with harassment campaigns, doxxing, and threats of physical and sexual violence, that sentiment doesn't go unnoticed. And it doesn't go unappreciated.

At its core, Borderlands questions the very nature of heroism, but with its satire and inclusive storytelling, it makes it clear that anyone and everyone could be a hero. And while Borderlands is a silly game at times, what it does and what it means for so many isn't silly. Not by a long shot.

1

The Lay of the Land

In a 2013 panel at the University of Southern California School of Cinematic Arts, Steven Spielberg and George Lucas took video game storytelling to task. Lucas said, "Telling a story, it's a very complicated process . . . You're leading the audience along. You are showing them things. Giving them insights. It's a very complicated construct and very carefully put together. If you just let everybody go in and do whatever they want, then it's not a story anymore. It's simply a game."[2]

This criticism of games ignores the fundamental beauty of the potential of storytelling in games: you're creating a story along *with* your audience, rather than just giving them a story to consume in its entirety. Roger Ebert, famously, took down video games by referring to them as inferior to literature and film. "Video games," Ebert said in a follow-up Q&A post on

his own website, "by their very nature require player choices, which is the opposite of the strategy of serious film and literature, which requires authorial control."[3] This loss of complete and total authorial control isn't to be feared, but rather to be embraced.

Players will always bring an element of themselves to the story they're experiencing (be it their understanding of their character, the way they believe their actions fit into the world, their perceptions of the events in the world, etc.), and a writer and narrative designer's job is to create a story that can account for this level of interactivity, the emotional and mental input from the player. It's about giving players the tools to experience a story in a less rigid, or traditional, way. There is still structure and authorial control, but the author's intentions are no longer the only factor at play. Rather than being a strategy that limits narrative impact, inviting in player agency dramatically expands the potential of what a story can say, achieve, and mean to the audience. Just because it's different doesn't mean it's less than. Yes, it's a game. And yes, this comes with its own unique challenges. But it's not "simply" a game.

While apprehension toward the quality of storytelling in video games is not new, dictating that video games will *never* be able to achieve great storytelling feats is incredibly shortsighted and misinformed. Film directors who don't engage in video game storytelling won't know the potential inherent in video games, especially when there's a basic misunderstanding of how traditional storytelling devices are employed. For

10

example, at the same USC panel, Lucas went on to say, "By its very nature, there cannot be a plot in games."

All due respect to Lucas, Spielberg, and Ebert, but they vastly underestimate what video games have achieved and join a long history of naysayers who've decried the quality of storytelling in this art form. Plot is the linked events that cause a story to move forward, and we see plot in the entire Borderlands franchise, within and across games. In *Borderlands 1*, you open the Vault, which releases Eridium (a form of special currency introduced in the second game) into the world, which enables Jack to imprison Angel to charge the key to open an even greater Vault so that he can try and become the ruler of the world in *Borderlands 2*. Eridium also makes Lilith stronger; she becomes a force to be reckoned with in taking down Jack. Plot is arriving on Pandora as a mercenary to become something like a hero, only to have your actions create the ultimate villain, who drives the events of the next two games.

Not only does plot exist in video games, but the mechanics serve to reinforce the story, especially in games like Borderlands and other shooters. The game mechanic is to defeat increasingly challenging enemies by shooting them, which directly echoes the plot: shoot a lot of enemies that are trying to kill you while you try to find the Vault. As you play, you become more skilled, and your character also becomes stronger, leveling up, learning new skills, and growing in both skill and reputation. Narratively, this makes sense. The closer you get

to the Vault, the stronger the enemies you encounter, and the higher the stakes become as you near the endgame. The plot is fueled by the play mechanics: shooting this thing causes this other bad thing to happen, which is now the main bad thing you must fight to save the world. You're not just watching plot unfold, you're enacting it.

The game's loot system has a similar effect: players need guns, money, and equipment, and the more loot they scavenge, the better they progress through the game. Borderlands is essentially the story of a treasure hunt, and you're the one collecting treasure. *Borderlands: The Pre-Sequel* (*TPS*) introduces the Grinder, a machine that lets players put in three weapons of the same rarity level in order to randomly create a new weapon of a higher rarity level. All those weaker weapons that players find through random loot drops come to mean something — you can create something really cool. It expands the game's universe so beautifully: find the weapon you need to be the strongest and to therefore survive, or, if you can't do that, create a stronger weapon out of the weaker guns. It's crafting, as is common in many RPGs and FPSs, but by blending it into the game's randomized system, it breeds more exploration and looting, which furthers the main plot of a bloody, murderous treasure hunt.

These mechanics also reinforce the main theme of the game and the myths that made Pandora what it is: nobody is born special. But anybody can *become* special.

Beyond plot, video games have also proven their capacity to create fully realized worlds where vignettes flesh out the

universe in subtle and meaningful ways: outside of the main narrative, you can lose countless hours exploring side missions. For example, in *Borderlands 1*, there is the side mission "Wanted: Fresh Fish": there are fish in the sludge on Pandora, but they're rare and not easy to get. Subtle and deceptively simple, this side mission shades in so much detail about life on Pandora: it is hard, food is rare, environments are poisoned by sludge, and sometimes the best way to catch fish is to bomb the water they live in. "Wanted: Fresh Fish" tells us what we need to know of the land: "fresh" is a joke because Pandora has little fresh food, but people still need to find sustenance on this planet.

By their very natures, games — especially open-world games like the Mass Effect series or those that prioritize storytelling like *Deus Ex: Human Revolution* (2011) and Borderlands — provide a unique storytelling opportunity to create vignettes that flesh out the world and the main plot without being intrusive. A writer or narrative designer might not be able to maintain narrative tension in a game the same way a film or novel does, but that doesn't mean the storytelling feats of video games are any less worthy or compelling.

In *Mass Effect 3* (2012), while on the Citadel — the main intergalactic hub in the game's universe — you can overhear conversations. Sometimes these conversations lead to quests, but other times they are simply there for environmental storytelling (the act of creating an immersive narrative experience through the settings and locations player characters find themselves in). *Mass Effect 3* takes place during a war, when humans

and aliens are faced with seemingly inevitable destruction by an ancient alien race that periodically wipes out all other races. On the Citadel, a player can choose to listen in as a woman, affected by memory loss, repeatedly approaches a young receptionist to inquire after her missing son. The receptionist, though exhausted by this sad conversation, always entertains the woman's pleas, always engages her. Not only do we see the way civilians react to the war, and the loss everyone feels, but this interaction also shows the empathy people have for each other in such times. The receptionist gives the older woman hope and shows her kindness.

It's a conversation found only by the player exploring their surroundings (an agency readers and movie-goers do not have), and it subtly extends the story, as "Wanted: Fresh Fish" does. In *Mass Effect 3*, this overheard dialogue shows the player how devastated humanity is by the war without telling us "Humanity is devastated." It's heartbreaking, and it's beautiful — an incredible example of the depth of the story in the game. And it's left entirely up to the player to discover. To a certain extent, video games offer players stories at their own pace and tailored to their own desires. If a player just wants the main story, they can choose to stick to that plotline. But if a player wants more, there is usually more to discover. It's a kind of reactive storytelling open to a variety of audiences.

In his book *Half-Real: Video Games between Real Rules and Fictional Worlds*, Jesper Juul describes fictional worlds as being incomplete and writes, "In most cases, the incompleteness of a fictional world leaves the user with a number of choices in the

imagining of the world."[4] While incompleteness is not unique to video games, it makes video game worlds like Pandora in Borderlands so wonderful to occupy. You can explore, but there will also be bits left up to our imagination to fill in. (What does that "fresh" fish taste like? Probably electrified sludge, but it's up to the player to imagine.)

Juul elaborates, "Marie-Laure Ryan [a prominent literary scholar and critic] has proposed the principle of minimal departure, which states that when a piece of information about the fictional world is not specified, we fill in the blanks using our understanding of the actual world." The beauty, allure, and mystery of Pandora and Elpis (Pandora's moon, the icy main setting for *The Pre-Sequel*) is compounded by the perfect balance of information and design (these worlds are Earth-like, but are inhabited by uncanny monsters not found on Earth), which leaves room for a player to fill in the blanks. And everyone's Pandora is likely a little bit different, depending on what information they've gleaned and how they've filled in missing bits with their imagination.

Rather than create codices on all the species, technology, and planets in the universe in the way that the Mass Effect series does, Borderlands is content to let you, the player, explore the world, creating your own individualized ency-clopedia from the main plot, side stories, overheard bits of conversations, half-remembered snippets from a history text-book, and your imagination. The only way to understand the fictional world of Borderlands is to live in it, to talk to the characters, and to immerse yourself in the fiction. This level of

interactivity doesn't limit the story being told. Rather, it opens it up, inviting the players to discover its pieces and stitch them together to craft a more fleshed out and meaningful story.

2

Making History of Myths

Reading reviews of *Borderlands 1* on the website Common Sense Media, written by parents whose children are either interested in buying the game or currently playing it, yielded an interesting perspective on the game. One parent warns that it includes "incest and liquor-induced cannibalism," which is not wrong, not even in the slightest. Another review boiled *Borderlands 1* down to being about "people who try to find gold and technology."5 The four-sentence review doesn't say much else about the game, and I love that rather than remarking upon the crass humor, sexual innuendos, violence, cannibalism, and all the other very clear aspects that make it a very mature (immature?) game, this parent deftly identified the whole crux of *Borderlands*. Its surface is crude and vulgar,

but underneath that offensive and outrageous exterior lies a simple treasure hunt.

The key to any good treasure hunt is not just the promise of loot, but a rich and believable legend, dating back to before living memory. Its own history. Of course, history is not born fully constructed and ready to be read, but instead is created from both archival materials and the stories we tell. History is a story, a legend bolstered by records. The academic scholar Linda Hutcheon famously coined the theoretical term "historiographic metafiction" to refer to postmodern stories that weave intertextuality, history, and metafiction together to reveal the ways in which history is constructed. Hutcheon writes, "Historiographic metafiction . . . represents a challenging of the (related) conventional forms of fiction and history through its acknowledgment of their inescapable textuality."[6] Both fiction and history are texts, constructed through similar acts of storytelling built upon recorded data. In Borderlands, we see the Vault Hunters embark on a treasure hunt, weaving a new story while at the same time creating history: their actions are both history and a story, and the game itself becomes a living emblem of this dynamic. But the true catalysts for everything that occurs on Pandora and in *Borderlands 1* are Marcus and Tannis.

From its very beginning, *Borderlands 1* establishes the importance of Marcus's storytelling: "So you want to hear a story, eh? One about treasure hunters? Ha ha, have I got a story for you!" He both invites and challenges the player, as he takes obvious pleasure in being the storyteller. Marcus recounts the

history of Pandora and its mythology. As he details the legacy of the Vault on Pandora, he introduces us to the playable characters in their typical gaming roles: Roland as the soldier who can deal damage per second (but he is also the healer of the group, a break from typical characterization in games); Mordecai, as the sniper and long-range character; Lilith, as the siren and magic user. Then Marcus shifts away from the framework and introduces Brick as "himself," which tells us that Brick is a tank character designed to eat up and deal a lot of damage. But by saying "himself," *Borderlands* is hinting that it won't just follow in the well-trod footsteps of other games. It's pointing at these footsteps. And stomping on them, or veering off trail. Marcus winks knowingly at the player; he embellishes, alters, derides, and snarks as he takes his own route through the story as only a bus-driving business man could.

As storyteller, Marcus's importance is paramount: without him, the story of the Vault and the Vault Hunters would never get told. And if it doesn't get told, it can't inspire. Pandora exists as it does because of its mythology inspiring others to become Vault Hunters or megalomaniacs in search of ultimate power. Without the legend of the Vault, there would be no Atlas, no Dahl, no bandits and mercenaries — no civilization on Pandora.

Mythology in Borderlands is not a throwaway element. It is the very backbone of the entire game, the entire world, and all the characters. There is nothing in Borderlands that is not, in some way, influenced by the power of mythology. "My father would always go on about the Vault, even with his

dying breath," Marcus says. The legend of the Vault tantalized everyone with the promise of something more, something that would drive people to inhabit a dangerous, desolate waste-land. Legends and myths aren't just idle stories. They inspire actions. They inspire identities. As Marcus says, "So you can understand why some little kiddos who hear the stories grow up to become Vault Hunters."

But there would be no story for Marcus to tell without records of the Vault left behind by Tannis. In both *Borderlands 1* and *Borderlands 2*, Tannis's ECHO recordings (voice record-ings left behind by previous inhabitants or other people in the world) feature prominently as a way of disseminating critical information to the player. As the main researcher and archae-ologist investigating the Vault, Tannis is a wealth of informa-tion and the primary source of everything officially recorded about the Vault.

Tannis's investigations — the scientific fact that backs up and informs the current mythology of Pandora — are directly mired in legend, though. In her second ECHO recording that you find in *Borderlands 1*, Tannis explains, "When I attach scientific inquiry to something like the Vault, I am greeted with silly nursery rhymes and slack-jawed soliloquy about a man who knew a man who knew a man." Tannis researches by sifting through the legends that have been passed down orally, which exist only in shared stories. In many ways, Borderlands prioritizes oral history as both a means of entertainment and a cultural record, because scientific methods become compro-mised by the myths and legends that inform everything.

Tannis's scientific training, oddly enough, is what keeps her from initially grasping the truth of the Vault. It's not until her 76th day on Pandora, 33 days after her ECHO recording deriding the orality of the legends of the Vault, that she begins to make headway in her research. In this ECHO recording, she details the death of Carl, one of her colleagues. Importantly, Carl's death also signals the beginning of Tannis's breaking point with reality. "My . . . emotions are deadened and I grieved for none of them," Tannis explains. "In point of fact, the only emotion I felt was that of joy. I felt joy because his chair was always more comfortable than mine! I took his chair. And then I noticed the emissive glow on the rocks at the dig site." That emissive glow is the first sign of the Vault that Tannis — or anybody on Pandora — discovers. Life on Pandora had ruined Tannis's mental faculties, ensuring her eventual spiral into madness. But it is not until this madness peeks out that Tannis begins to discover the truth.

Despite Tannis's faltering sanity, she achieves what no one else could: she deciphers the Eridian writing with a computer program. She concludes of the Vault, "It's not a myth. It is real." But it is both at the same time — a myth and real — and this is what makes it so powerful.

Tannis uses myths to find the reality of the Vault, and Marcus uses Tannis's findings to tell further stories about the Vault, creating a living, growing myth. As you play Borderlands, you witness the formation of myth and history, with Marcus spinning the information Tannis provides. But this goes further than just watching a myth unfold: as players,

we get to explore the myth and create the history at the same time, highlighting the interconnectedness and textuality of history that Hutcheon outlines in her historiographic metafiction theory.

The player also acts as historian, filling in the gap of their knowledge from multiple sources, both stories and data recordings. Many of the missions in Borderlands revolve around collecting ECHO recordings, which often detail important pieces of history or tips about current missions and function as primary sources about the early days of settlement on Pandora.

Everyone who plays Borderlands gets told the same story to a certain extent, but how much more of that story players take in depends on how much attention they pay to the facts they uncover, the tales they hear, and the nooks and crannies they choose to explore. But beyond this, Borderlands encourages players to see how bias informs history by showing them the way it is constructed and letting them piece together a history of their own. Comparing Tannis's ECHO recordings to Marcus's story shows players the competing narratives at play, and how certain powers (like Hyperion) try to control how this history is written. It also shows that history is informed by perspective: what I focused on in Borderlands might be different from what someone else did, creating two valid, connected, but different versions of the same events.

The story Marcus begins *Borderlands 2* with is the story of *Borderlands 1*; the glory he recounts is the glory the players achieved in the first game. By playing through the entire

series, players are effectively creating the story of the series. Marcus, therefore, isn't just telling the players a story: he is telling the players a story about their own actions as the first set of Vault Hunters from the previous game, creating both an oral history and the beginnings of myth.

When we are left without a reliable archive and only disparate pieces of data, such as the ECHO recordings, our knowledge of history is based solely on stories, told with all their inherent bias. We see the Vault Hunters as heroes because Marcus says they are. But what if it wasn't Marcus telling the stories or Tannis reporting her findings? What if it was the child of a bandit killed by a Vault Hunter? What if it was Jack himself? Who tells the stories matters as much, if not more, as what the stories say.

In *Tales from the Borderlands*, Marcus is at it again, this time more explicitly focusing on the importance of storytelling, especially as it relates to history. "History's attention is fickle, my friends," Marcus says during the introduction to *Tales from the Borderlands*. "It will remember those pirates like Handsome Jack but forget the adventurers who risk it all for less . . . ah, obvious rewards. Stories — legends — those are much better at getting at the real spirit of things. Stories remember both sides of the tale."

Borderlands defies any notion of history as absolute and reveals that the real backbone of its history is the way people weave together archival material with storytelling. In *TPS*, Janey Springs remarks, "I guess stories don't have to be true to be believed. They just have to be told." The treasure hunt

central to the plot of Borderlands hinges on that belief, a story made real by the people telling and sharing it. The history the Vault Hunters create becomes its own mythology, inspiring others to dare to believe in monsters, heroes, and, of course, unspeakable treasure.

3

"I Fart Rainbows": The Humor

Undeniably, one of my favorite things about Borderlands is Butt Stallion. Butt Stallion is a pony made of diamonds. A living, breathing, gun-pooping diamond pony, who defies all logic but is the embodiment of pure happiness (for me, anyway). Because she poops loot. And because she's made of diamonds.

Okay, so let's back up. In the Southern Shelf, one of the very first maps in *Borderlands 2*, Handsome Jack (the villain of the game) tells the Vault Hunters how he bought a pony made out of diamonds. Not a statue — an *actual* pony made of diamonds. He taunts them, saying he was going to call the pony "Piss for Brains" in honor of the Vault Hunters, but opted for Butt Stallion.

And a legend is born.

Butt Stallion is a way for Handsome Jack to berate the Vault Hunters, to egg on the players. See, kiddos, he's so rich he can buy a living pony made of diamonds! Jack's attempts at annoying the Vault Hunters motivate players to want to punch his face repeatedly. But Butt Stallion becomes so much more than just a rhetorical tool and a character only heard neighing off-screen.

In the *Borderlands* 2 downloadable content (DLC) *Tiny Tina's Assault on Dragon Keep*, Butt Stallion becomes a character players can interact with. She's been rescued from Jack and now lives in a safe and quaint medievalesque village with the other non-player characters (NPCs) of Borderlands. You can feed Butt Stallion Eridium and Butt Stallion will either poop an average item, or she will throw up a better, rarer item. I mean, the joke is on us players who find something legendary and valuable in Butt Stallion's feces. You can also pet Butt Stallion, which doesn't give you anything but is wonderful to do nonetheless.

And you can do this forever, depending on how much Eridium you have. (And if you're playing this DLC, you've probably beaten the game and have *a lot* of Eridium.)

Butt Stallion represents two very important things in the Borderlands world. The first is how ridiculous the game is. Friends, *Butt Stallion is a real character*. She even makes an appearance in the spin-off game *Tales from the Borderlands*. Borderlands has created a world where Butt Stallion can and does exist. And that kind of ludicrousness is important in understanding Borderlands' satirical vein. Nothing is sacred

in this game, nothing too ridiculous, and no line will remain uncrossed. Borderlands isn't going to gently toe the line of genre conventions: it's going to suplex them into a shark tank.

The second is that Borderlands, largely apart from other AAA video games, operates entirely in its own realm of strange humor. And this humor is crass, dark, and endlessly caught in pop culture references. The in-game achievements are constantly making references, metafictionally winking at players, for sheer fun. There's an enemy called Tankenstein, which, as you can guess from the name, is the monster Dr. Frankenstein would have made if he was a little bit more into tanks and heavy weaponry. One of my personal favorites is the Xbox 360 achievement titled "Can't We Get *Beyond* Thunderdome?"

One of the maps you have to traverse is called Ore Chasm, a delightful play on "orgasm." Ore Chasm is home to Innuendobot 5000, a robot reprogrammed to speak only in wonderful, sexual innuendos by the NPC bartender, mission-giver, and beautiful badass Mad Moxxi. Which is silly, crass, and wonderful. The entrance to Ore Chasm is through Human Dwelling Place, home to Mal, a robot who really wants to be a real human (a reference to *2001: A Space Odyssey*'s murderous AI HAL 9000). Mal tasks the players with finding human garments for him to wear, eventually escalating to the point where Mal wants players to dismember enemies so that he can wear their body parts in his attempt to become more human. Which, you know, the Vault Hunters do willingly.

While Innuendobot 5000 is pure fun, Mal cuts a little deeper with his dark humor. When obtaining his missions,

Mal says, "I cannot wait to be human, so that other humans can discriminate against me due to physical or mental conditions I was born with!" and "When I am human, I will never ever think about the black void of nothingness that awaits me when I die, because that could take up a lot of my time!" Mal can be heavy handed, but he gets the point across: humanity can really suck, a tone radically different from Innuendobot 5000 saying, "This combat will be long and hard — wink," and "What a spectacular climax!"

But Borderlands allows for both types of humor to coexist, and to never feel ham-fisted (unless intentionally made to feel ham-fisted, and unless turning the word *ham-fisted* into an inappropriate innuendo). Humor in Borderlands serves so many purposes at once: it's meant to make us giggle, but it's also there to challenge our typical understanding of an FPS game and the community that surrounds it. Innuendobot 5000 makes us laugh, providing comic relief during really hard combat, while Mal points to our flaws as humans. A lot of humanity's capacity for toxicity shines in multiplayer games, like FPSs, where strangers interact with each other. Borderlands' humor stands out because it calls FPSs on their failings — and manages to be silly and funny in a genre that rarely is.

Reviews of *Borderlands 2* often focus on two things: it's gorgeous and it's hilarious. But lead writer Anthony Burch, in a development log about *Borderlands 2*, is very firm on one thing: "Borderlands is *not a comedy game*."[7] He explains that, first and foremost, *Borderlands* is a shooter, and that anything

they did — adding humor or otherwise — would be in service to the mechanics found in typical shooters. And since, as Burch notes, there's nothing really funny about shooting a lot of people, building humor into the game design was a bit tricky. This is why satire in Borderlands works so well: it embraces the terribleness of shooting in FPS games in order to show how terrible this mechanic can be sometimes. Satire in Borderlands rips off the veil we have covering the worst parts of gaming and exposes it for us all to see.

In the same development log for *Borderlands 2* on designing humor, Burch explains the story of a gun: The Bane. A gun I despise, despite it being an extremely powerful elemental SMG (a submachine gun). After a discussion with Burch and creative director Paul Hellquist, Borderlands creator Matthew Armstrong designed a quest that riffed off *Winchester'73*, a film starring Jimmy Stewart about a cursed gun that kept killing its owners. So Burch and Hellquist created The Bane. (The play on words in naming the gun isn't lost on me, either.) After you complete a specific quest, you're rewarded with The Bane, and, Burch explains, "once you look at its stats, they're incredible — it's entirely likely that this is the best gun you've yet found in the game."[8]

Great! *Great*. For someone who always plays Borderlands with an SMG because I like the fast fire rate, finding an elemental SMG with over 180 damage this early on in the game is *kind* of incredible. I was blown away.

Then I was furious. With The Bane equipped, your movement speed is slowed down considerably, so that there is no

way you can effectively carry this weapon and enjoy the game at all. But that's not all. The Bane makes the *most annoying noises I've ever heard in my life*. When firing, the gun might just shout "YEAHYEAHYEAHYEAHYEAHYEAH" (which is subtitled with "[annoying sound]") ad nauseam. And it does this *all the time*. When you shoot, reload, or *even when you switch away from The Bane* (it shouts, "Swappin' weapons!"). Oh, and that's not all either. The noises are programmed to ignore your in-game volume control. As Burch says, "They always play at max volume."[9] When you're using The Bane, you can practically *hear* Burch and Hellquist giggling.

As much as I despise The Bane, it's a brilliant example of how humor is designed in the Borderlands franchise: it's unexpected, it's referential, and it tries to be all in good fun. It satirizes the desire in FPSs to always search for stronger weapons to be a more efficient killer. The Bane makes you incredibly inefficient. Beyond providing comic relief and celebrating video games' pure ridiculousness, the jokes in Borderlands serve to undermine the status quo, to challenge the accepted systems in place. In *Borderlands 2*, Torgue tells the Vault Hunters, "Right now, you're ranked 50 in the badass leaderboards, which puts you behind my grandma but ahead of a guy she gummed to death. IT TOOK SEVERAL HOURS," which torpedoes the typical FPS mentality that playable characters are the ultimate best and most badass of all time — and definitely way stronger than a grandmother. This joke is silly, but also shifts the way power is viewed in Borderlands: grandmothers can gum dudes to death, nobody is safe from this

ridiculous violence, and taking yourself seriously as a badass hero is impossible.

This isn't something that should be taken for granted, either, because not all humor in games works. In an article for *Forbes*, Paul Tassi weighed in on the game's humor: "Games often try to be funny, but in the end, things can go . . . awry. *Duke Nukem Forever* [2011] is the prime example of the anti-*Borderlands*. It's a game that doesn't take itself seriously, which is a good start, but its jokes are stale and forced, and despite crudity or pop culture references, they fall flat."[10] For me, *Duke Nukem Forever*'s jokes miss because the game isn't actually trying to say anything through its humor the way Borderlands does.

In a game-development tutorial, game developer Matthias Zarzecki explains the comedic timing of dialogue in games like *Portal 2* (2011), where GLaDOS, an AI in the game, narrates certain events. GLaDOS is funny and intentionally so. But of writing explicit jokes in dialogue, Zarzecki cautions, "But make sure to not overdo it. Because no matter how brilliant a line or gag is, people will grow to hate it if they're continually bombarded with it."[11]

Effectively the use of intentional humor in games should be limited to well-placed and sparse jokes in dialogue. But Borderlands follows neither of these rules. Borderlands takes this subtlety and boots it out the window. It overdoes jokes, inserts them wherever (wink, wink), and calls itself out on doing this. And it works because it's established early on that this game doesn't take itself too seriously all the time.

Because, you know, games about mass murder should maybe not take themselves too seriously. For obvious, not celebrating sociopathy reasons. The difference is that Borderlands knows when it needs to take itself seriously: for example, when characters are learning how to grieve or taking stabs at the misogyny ingrained in nerd culture and video games. Often, Borderlands' humor "punches up" — that is, it takes shots at those in positions of power, like misogynists, using it as a political weapon. It knows when to have Torgue shout, "Know what's badass? Respect for women!" to challenge the ways women are often treated in FPS communities and at events. But Borderlands also knows when to be silly and just have fun.

And this isn't an easy line to walk. There are missteps — nothing is perfect, especially when it comes to inclusivity and especially when it comes to video games — but Borderlands tries. It explicitly tries.

In a review of *The Pre-Sequel* for *Rock, Paper, Shotgun*, Jim Rossignol notes, "There really are some good jokes amid the screaming mania of it all. That won't do much for the decided Borderlands grumpyfaces, and that's fine, but at least this game means what it says."[12]

Borderlands is over-the-top, it is absurd, it is silly, and it is poking fun at almost every trope and convention inherent to video games and popular culture. But it means what it says. If it's poking fun at toxic masculinity tropes, it means it. If it's correcting misogynistic language and behavior, it means it. If it just wants you to have fun killing as many enemies with as ludicrous a weapon as possible, it means that, too. At the same

time, it is so silly as to be borderline obnoxious. Borderlands isn't afraid to be ridiculous, but it's also not afraid to use humor to say something important.

4

"A Day without Slaughter Is Like a Day without Sunshine": Megacorporations and Violence

When I first met my roommate and best friend, we were barely more than colleagues who happened to share a few of the same interests: dogs, coffee, wine, and Batman. They were more than enough to create the foundation for what has become TV-show-level-ridiculous best friendship. Little did I know, my extreme enthusiasm for Borderlands and all of its available weapons almost finished off our friendship before it even began.

A dedicated book lover and comics fan, she had not yet discovered the rich and evocative worlds that video games offered. So when I was giddy with excitement about the 870 gajillion new guns in *Borderlands 2* the summer prior to its release, she (fairly) thought I was an NRA member in disguise. But after letting me rant for days, weeks, and eventually years,

she gave in and gave *Borderlands 1* a shot. And quickly realized that there is so much more to this game than she ever thought possible.

But, of course, it's wrapped in a caustic shell and navigated by way of many, many, *many* guns and so much violence. In many ways, the guns themselves have their own personalities. There's The Bane, mentioned in the previous chapter. There's the Double Penetrating Rod (wink, wink), a pistol that deals double damage and consumes two ammo per shot. There are Miss Moxxi's SMGs: Miss Moxxi's Good Touch and Miss Moxxi's Bad Touch (which vibrates the controller in the player's hand *constantly*). There's also a pistol called The Fibber, which has the flavor text (text that doesn't offer any stats about the gun, just a bit of personality) "Would I lie to you?" All of the stats shown for this gun are, in fact, false, and the real stats are unknown. There's even a legendary gun called Morningstar that has a random chance of saying, "That's murder by most definitions," after you use it to kill, a hilarious and unsettling way to remind the player how violent the gameplay is. By creating guns that can talk — and often do — Borderlands acknowledges both the terribleness of murder (Morningstar will also say, "Most serial killers thought they were good people, too.") while also using the murder as part of its humor. Shotgun 1340 doesn't moralize, but instead celebrates its power: it will often just shout "KILL KILL KILL" or "DIE DIE DIE." The shotgun's counterpart, 1340 Shield, trash-talks your enemies. It might say "Ow!" when hit, either

implicating a level of feeling in the item or just trying to make its user feel terrible.

Though these guns might be guilt-trippy, violence is the only way to survive on Pandora. As an FPS, the game's main mechanic is shooting, and so violence is the only way to survive in a world run by megacorporations — Dahl, Atlas, and Hyperion to name a few — that are desperately trying to claim all the power and wealth. In Borderlands, violence isn't just violence: it is manufactured, just like the guns. It is created by capitalism to serve capitalism's end, and this narrative doesn't allow for clean heroes. In *Borderlands 2*, the mission where the player can obtain either the Shotgun 1340 or 1340 Shield is called "Hyperion Contract 873," and the only goal is to kill a certain number of bandits: "The Hyperion corporation is offering you a unique gun if you kill the requisite number of bandits for them. Though you would be wise not to trust Hyperion, a reward is a reward, and a dead bandit is a dead bandit." Incredible systemic violence is business as usual for these almighty corporations.

Violence in video games is a well-trod subject, with the discussion ranging from whether it makes people more aggressive (but not necessarily more likely to engage in violent activities) to whether it is responsible for causing real-world gun violence. The studies are varied and the conclusions contradictory, but one thing is known for sure: games tend to include a lot of violence, and, sometimes, this violence feels very good (mechanically and in terms of game design). As "Hyperion Contract 873" stipulates, players must kill bandits in a variety of ways,

such as with fire, with corrosion, with shock, and with explosives. Killing 100 bandits isn't tedious when you have different objectives about the *way* you kill those bandits, creating a more playful mission. And Hyperion knows this. Additionally, the Vault Hunter needs at least four different weapon types, which if they don't have, they can purchase at a gun vending machine almost anywhere on Pandora.

In a chapter called "The Joy of Virtual Violence" in *The State of Play*, Cara Ellison and Brendan Keogh wrote letters to each other examining the nature of violence in video games and why it feels so good. Ellison elaborates on Doom co-creator John Romero's theory that video games are about cleaning up and ordering messes, to which Keogh responds that for him it goes deeper, examining the dual nature of creation and destruction. The two get into a discussion of how so many Western games, especially games focused on shooting, follow a distinct colonial narrative. Ellison explains:

This reminds me of the way the Far Cry series [2004–2016] treats environments simply as places to be cleansed of enemies (often enemies explicitly coded as other or foreign to the player), then asks the player to collect and upgrade things for themselves. In a way, this is destroying and creating (oneself), but it's explicitly a colonial narrative: one where the player knows best, the one where the player is ordering things by destroying, one where the consumption of the environment is self-improvement.[13]

In Borderlands, Vault Hunters destroy everything in their way, leaving a pile of destruction and dead bodies, while also upgrading their own skills and creating more skilled and more efficient versions of themselves. Guns destroy, but also lead to creation: but only for the colonialist is this a good thing. These corporations moved into Pandora, creating settlements and attempting to reorder the landscape, an act that speaks to the ways violence becomes justified in some video games. This world is violent, so it must be met with violence.

Ellison speculates, "Perhaps it is something to do with survival. Are violent images pleasurable to experience, because they tell us we are surviving?"[14] But in Borderlands, it's not just a matter of survival. Sure, the bandits and psychos are trying to kill almost anything, but these people were brought to Pandora as convict workers in the Dahl mine. So who is fighting for their survival?

In the world of Borderlands, violence not only ensures survival (the cost of this will be explored later), but is subjected to the same kind of myth-making apparent in the rest of the game. But rather than having the characters fetishize their violence, Borderlands uses the corporations that create weaponry to bolster this mythos of empowerment through violence.

Atlas, one of the leading corporations in the Borderlands world, uses mythic language and imagery to brand itself as a God, benefiting and supporting all of the world. Atlas itself is the name of the primordial Titan who was forced to hold up the world on his shoulders, as punishment by the Olympians.

In the official guide to Borderlands, Atlas's sales pitch even invokes Zeus:

> It is said that the Greek god Zeus fought for ten long years against the Titans, only to have the battle end in a draw. We at Atlas like to believe Zeus could have won the fight in half the time if only he had one of the guns from our legendary line of firearms. . . . Regardless of your god, you need not look to the heavens for salvation from adversity. Atlas weaponry can answer your prayers and grant you a power few mortals have ever experienced. Prove yourself as a true believer. Join the select ranks of Atlas owners and become a god among men!

Atlas's sales pitch is loaded, tapping into the player's need to feel strong and to become stronger than everyone else around them. Words like "legendary" and "epic" play into the fantasy of living vicariously through ultra-powerful protagonists; the pitch mobilizes players to *want* to play with Atlas weapons. We're not meant to trust these corporations, since dead bodies are good for their bottom line, but as the "Hyperion Contract 873" mission said, "a reward is a reward and a dead bandit is a dead bandit." In short, you don't have to believe the propaganda, but it might make all the killing easier. In Borderlands, we can never fully engage in the power fantasy that is typical with FPSs because we're always being shown that this power isn't inherently ours. Instead, we are

just borrowing power from these megacorporations that want us to destroy everything around us. Sometimes in Borderlands it feels less like we're playing as heroes, and more like we're pawns in a larger narrative we can't control.

Atlas is more than just an arms manufacturer, though. It's an interplanetary megacorporation that produces starships and stardrives, and was the first to discover alien technology. Atlas's reverse engineering of the alien tech led the human race to advanced space travel. Thanks to Atlas, humanity can travel the universe, no longer restricted to life on Earth. This corporation realized the idea of settling other planets and gave the power — through their firearms — for others to do the same.

The corporate actions of Atlas and Dahl drive the important narrative moments of the games in the series — Pandora's and Elpis's settlements were created by these corporations, Atlas begins the search for the Vault, Dahl employs Tannis, Dahl and Hyperion go head-to-head on Elpis. These corporations create the world they want to inspire. That is, a violent world that needs the firearms they are selling, where violence is self-perpetuating.

But these corporations are fallible, subject to the very violence they sanction. *Tales from the Borderlands*, set in Pandora after the events of the original games, investigates the fall of Atlas: Handsome Jack has been defeated, Hyperion is a shell of its former self, and Vaults are slowly being reduced to a commodity bartered on the black market.

Tales follows Rhys, a low-level Hyperion employee who dreams of becoming a legendary CEO like Jack was, and

Fiona, a con artist trying to keep her sister, her adopted father, and herself alive. Jack and Fiona discover an old Atlas bunker, filled with Atlas tech, records, and deceased employees — a relic of what Atlas once was and stood for. With Hyperion the now-ruling corporation, and Jack's shadow — even after his death — looming over every action on Pandora (and Elpis), Rhys and Fiona accidentally stumbling upon an underground Atlas bunker feels like they're explorers discovering ancient ruins. The bunker is dark, dank, and dusty, but the awe emanating from Rhys and Fiona is palpable: they know they are in the presence of greatness. They are witnessing the ruins of a legend, brought down by the very violence that the corporation helped breed.

In this world, corporations are mythologized and given status as foundations of civilization, both current and lost, replacing any religious and/or governmental institutions once revered. On Pandora there are no governments, and religion is relegated to a select few cults; instead, there are corporations creating and destroying civilization with their every whim. The history of Pandora reads like Atlas and Dahl taking turns ransacking the planet, one corporation deciding Pandora is useful, placing inhabitants there only to later abandon them until the next corporation swoops in, destroys their settlements, and creates anew. This, as much as the invention of stardrives that allowed humans to trawl space, is Atlas's legacy.

While the events of *Borderlands 2* and *The Pre-Sequel* focus on the ways in which Hyperion's rule has a more overt and explicit effect on life on Pandora, there remains little of

the glory of Atlas aside from the stories. All evidence of Atlas has been wiped out, replaced by new corporate king Hyperion. In *Borderlands 2*, there are only small Atlas signs, often nestled among the corrugated roofs, and wanted posters for Atlas assassins. But most notably, there are no Atlas guns in *Borderlands 2*. And on Pandora, without guns there is no power.

Among the tyrants of the corporations, it is the individuals who stand out. They aren't necessarily more moral than the corporations, but their whims and actions use the power afforded by these corporations to carve out a life worth living. Marcus stands as a kind of antihero, protecting less violent people like Tannis (though it's worth noting that as a gun salesmen he has a vested interest in violent mythology too). Dr. Zed (a "doctor" without a license who keeps his medical vending machines running on Pandora) also uses the power of violence to take a stand. So does Rhys in *Tales*. But their violent acts of resistance are enacted with guns sold by the corporations they oppose. They may be taking the corporations down, but the violence-for-survival mythos these corporations perpetuate remains, even in the heroes. After all, Rhys and co. in *Tales* only survive by learning how to use weapons, by learning how to use violence to suit their underdog needs. No one is exempt from it, but on Pandora, violence can empower.

At the end of *Tales*, Rhys is disillusioned and betrayed by his hero and his friends at Hyperion, and he sets off in a new direction. No longer interested in being like the ruthless and rich CEO of Hyperion that Jack was, he redirects his ambition

to become a genuinely good force, what the megacorporation Atlas was in the legends.

The introduction to *The Secret Armory of General Knoxx* DLC features a speech from an Atlas educational film called *Respecting Your Superiors*; it gives us a glimpse of how Atlas tried to spin its own lore: "Pandora. A planet that once knew only peace and prosperity under the fair and noble direction of the Atlas Corporation. But there were those that sought to disrupt our perfect existence. Thieves and murderers. Perverts and scoundrels. The lawless garbage unleashed an unspeakable evil upon Pandora not known since the age of the Gods. But together, we shall not despair. Atlas has not forgotten you. We are returning and we will restore order and security to your planet. When we arrive, we will . . ."

Atlas promises to restore order, but, as Ellison and Keogh note, this is usually done through massive violence, especially in shooters. Maybe Rhys's rule of Atlas will produce a less violent existence on Pandora? I somehow doubt it. Violence in Borderlands is self-perpetuating, with even the Vault Hunters causing more and more violence. Like vigilantes, the Vault Hunters create destruction even as they aim to protect people. It's not just the villains who make Pandora unsafe; it's also the supposed heroes.

5

"Something Something Hero Stuff":
Killing Your Heroes

In his book *The Hero with a Thousand Faces*, Joseph Campbell writes, "It would not be too much to say that myth is the secret opening through which the inexhaustible energies of the cosmos pour into the human cultural manifestation."[15] Myth is at the center of how we understand ourselves and our world, and the same is true in Borderlands.

Campbell famously outlined the archetypal "hero's journey" as one of transformation: the hero enters into an extraordinary situation where they will be transformed by overcoming a series of challenging tasks. We see this narrative structure everywhere in video games, but particularly in The Legend of Zelda (1986 onwards) and the Final Fantasy (1987 onwards) series, where the protagonists receive a call to adventure that leads to epic transformation. In *Borderlands 1*,

Marcus tells us that the myth of the Vault inspired children to dream of being treasure hunters. And these treasure hunters became our beloved Vault Hunters, filling the archetype of a ragtag band of good-hearted mercenaries in a good-versus-evil story.

Despite the convenient archetypes, it's not so clear-cut for the heroes of Borderlands.

During the introductory cutscene for *Borderlands 2*, we meet the new player characters/Vault Hunters in the same fashion as in *Borderlands 1*: a lonesome skag wanders across the screen, and instantly we know it's destined for vehicular manslaughter. This time, the car helmed by bandits drags the skag along, as it chases a Hyperion train that roars past.

And then the song kicks in. Rather than the upbeat and tongue-in-cheek use of "Ain't No Rest for the Wicked" by Cage the Elephant, *Borderlands 2* uses "Short Change Hero" by The Heavy, which couldn't be more different tonally. "Short Change Hero" is a slower tempo, more thoughtful song about the disconnect between wanting to be the best and existing in hostile places and environments. Rather than inspire a sort of playful Wild West vibe, as "Ain't No Rest for the Wicked" does, "Short Change Hero" creates an almost pensive atmosphere to set up the major theme for the game: undermining the ideal of a hero.

While the song is playing, the Vault Hunters raid the train and fight off the bandits. We're introduced to Axton as the commando, the archetypal leader/hero; Maya as the siren, the mage; Salvador as the gunzerker, the heavy tank unit; and

Zero as a number, the robotic sniper character — the perfect team of heroes. The whole scene plays out like in a movie, making it clear that these characters fill archetypal roles with a metafictional wink at the player. *Borderlands 2* knows what it's doing and is inviting you along for the ride.

Handsome Jack himself, the villain of *Borderlands 2* and much of the Borderlands world, even comments on the convenience of these characters as heroic archetypes. He remarks that Axton is "courageous and driven," that Maya's "wisdom is matched only by her beauty," that Salvador "makes up with brute force what he lacks in subtlety," and that Zero is "the epitome of precision, the assassin." He mentions these attributes as a way of convincing the Vault Hunters to come to Pandora in the first place: these qualities make them strong, worthy of finding the Vault. But Jack then notes that these attributes are also why the Vault Hunters have to die, since they stand as the only force capable of stopping him.

In the first game, the Vault Hunters are painted more like traditional heroes than their counterparts in *Borderlands 2*. Roland, Lilith, Mordecai, and Brick stand in direct opposition to Commander Steele and work to protect the people of Fyrestone from bandits, and the world from those who would open the Vault for nefarious reasons. With the introduction to *Borderlands 2*, though, we're asked to question: are we *really* the heroes? The Vault Hunters make their way through the train and finally reach a dummy of Handsome Jack, sitting in a chair with his back to them (as all evil villains do). "It's cute that y'all think you're the heroes of this little adventure,

but you're not," comes Jack's voice from an ECHO recording hidden inside the dummy's body. It swivels around, revealing an impressive stack of explosives, just as the recording says, "Welcome to Pandora, kiddos." With that, the train explodes, sending bits of train and bandits and Vault Hunters flying across a wintery landscape.

And then the game starts.

While Jack has summoned the Vault Hunters to Pandora, it's not to request their help in locating the Vault, as would be the case in the typical hero's journey. Rather, the call to adventure's purpose is for Jack to kill them so they can't stop *him* from finding the Vault. "See, I just can't have some psychopathic murderers getting to the Vault before I do," Jack laughs, while betraying his deepest secret: he *believes* himself to be the real hero. He calls the Vault Hunters bandits, which is not actually that far from the truth. I mean, as a Vault Hunter, you do murder a lot of people in the game. Like, a lot of people. Thousands of people. Some probably — hopefully — deserving of their fate. And others. Well. Who knows?

When I first played *Borderlands 1* with my roommate — my aforementioned friend who was just slightly concerned about my zealousness for bombastic weapons — she got upset whenever bandits or enemies referred to our characters as mercs.

"But I'm not a mercenary," she would protest. "I'm a Vault Hunter."

There's a cognitive switch that gets flipped for us when we play these characters: they can't be bad, because we, as players, are fighting for good, both in terms of having a noble purpose

(saving the world) and in that we don't often see ourselves as the bad guys. But if you look closely, the Vault Hunters are borderline psychopathic. As writer Nick Dinicola says on *PopMatters* in his critical examination of morality in video games, "*Borderlands 2* pits antiheroes against assholes."[16]

In *Borderlands 1*, after the players win a few rounds in the first ever Circle of Slaughter, Chuck Durden (a pointed reference to Tyler Durden in Chuck Palahniuk's *Fight Club*), the man running the show, says, "The crowd ain't looking for a hero. They're looking to see someone die. Take your money and beat it." Pandora isn't a place where heroic acts are clean — they're covered in blood and viscera. Winning is not pretty, and the morality of it is questionable. Sure, the Vault Hunters are trying to protect people. But they're doing it by murdering a lot of other people.

At the Game Developers Conference (GDC) in 2013, Walt Williams, while still working for 2K Games — the publisher behind Borderlands and games like *BioShock* (2007) and *Spec Ops: The Line* (2012), two revered FPS games that also use narrative in dynamic, complex ways to drive gameplay — gave a talk called "We Are Not Heroes: Contextualizing Violence Through Narrative." Williams spoke about how they tried to "make violence meaningful" in *Spec Ops*.[17] For Williams, to make the violence more than just mindless killing, games must "embrace ludonarrative dissonance," a term coined by Clint Hocking in 2007.[18] Simply put, ludonarrative dissonance is the conflict between a game's story and the gameplay. Hocking used the term to describe how *BioShock*'s gameplay

and narrative are at odds with each other: due to the rules and the mechanics of the game, the player is forced to do things that the protagonist and the game's story wouldn't allow a hero to do (such as harvest little girls for their powers). But we accept it and move on because the game's mechanics trump the game's story.

In terms of *Spec Ops*, and arguably in Borderlands as well, embracing this ludonarrative dissonance means accepting that the protagonists are hypocrites. For Hocking, the ludonarrative dissonance in *BioShock* is insulting because it mocks the players for accepting the narrative framework built around the contradictory mechanics.[19] For Williams, embracing this hypocritical nature of games' protagonists allows for a more interesting exploration of violence. When we play as a hero trying to save people, but are forced to embrace the fact that this hero is murdering a lot of people, much more narrative nuance and complexity is added to the experience.

This is exactly what *Borderlands 2* does with Handsome Jack and the Vault Hunters. Jack calls the Vault Hunters bandits, assuring anybody who will listen that they are the scourge of Pandora. And he's not entirely wrong. Since Borderlands is an FPS — its core mechanic is shooting many enemies — the protagonists cannot be squeaky clean heroes. They are not Superman: they do, and they will, and they must, kill. So rather than letting this dissonance trip up any critical players, *Borderlands 2* fully embraces it. It says, "Yeah, sure, you're playing as the heroes . . . but are you really a hero?"

In the comics, the dubious nature of the Vault Hunter's

heroism is also directly called into question. Mordecai is developing a ridiculous plan to defeat a ridiculous boss, a plan which involves lots of wanton destruction and likely casualties. To Mordecai's plan, Lilith responds, "No. I *know* what you're thinking and that's disturbing even for us." "That's disturbing even for us" reveals the fact that Vault Hunters, ostensibly the heroes, actually get up to some pretty disturbing shit.

These aren't exactly the kinds of heroes you feel good about embodying. Salvador boasts a love of excessive violence, and only learns about the Vault after torturing a Hyperion soldier. (Admittedly, the soldier was trying to seize Salvador's hometown, but Salvador tortured him even after the danger was over.) Similarly, Axton was discharged from the Dahl military for blatantly disregarding the personal safety of everyone around him in his pursuit of personal glory. What motivates Axton is not a noble calling, but his ego. He joins ranks with the Vault Hunters in *Borderlands 2* to find combat that is more up to his standards.

Heroism is also a matter of perspective. Marcus saved Tannis's life, and to her, he's a hero. But Marcus is also one of the leading arms dealers on Pandora and is brutal and abusive to his customers. Who is labeled as a hero becomes personal, not objective. The same is true for Dr. Zed, the medic of Pandora and the healing counterpart to Marcus. Where Marcus has vending machines set up to sell ammo and guns, Dr. Zed has vending machines set up to sell shields and healing vials. But Dr. Zed lost his license due to not actually having a "med school degree," as he says. Yet he continues to practice,

anyway. And by practice, I mean sometimes cleave bandits open, and sometimes help people.

A "good person" on Pandora isn't necessarily equivalent to what qualifies as good in our real lives. And this moral dissonance is established in *Borderlands 2* with both The Heavy's "Short Change Hero" and Handsome Jack. Head writer Anthony Burch explains, "Given that the first game opens with a song that implicitly refers to the game's protagonists as 'the wicked,' and given that you kill and corpse-loot millions of things on Pandora, we wanted to at least partially acknowledge the inherently antiheroic nature of what you do as a Borderlands player. Making Jack a self-styled hero gave us an opportunity to deal with that theme directly: when he says that Pandora would be better off without Vault Hunters, we wanted you to wonder — just for a second — if he might actually be right."[20]

TPS takes things a step further. In a *Washington Post* article called "Forget Anti-Heroes: This Game Lets You Be the Villain," writer Hayley Tsukayama discusses the way *TPS* allows players to inhabit straight-up evil characters:

There have always been game protagonists who stray from the straight and narrow. Some games have tried to make the bad guy the hero before — most notably *Dungeon Keeper* [1997], which turns the common game and fairy tale trope of conquering a bad guy's lair on its head: instead, players defend their homes against plundering "heroes." And there are plenty of games out there that start players with a moral blank slate

and then let you become good or evil over time with every choice you make. But even with those options, there's often a player impulse to play through once as "good" so that you can be evil without guilt later. (No, really, there are studies that back this up.)[21]

But with *TPS*, players aren't given that chance: the only playable characters are villains from the previous Borderlands games, who work for Jack, the very characters we just played so hard to take down in *Borderlands 2*. But this is what makes *TPS* so fascinating and Borderlands so fun: it celebrates the part of the hero's journey that involves being kind of bad at times; in a way, it de-mythologizes the heroes we're used to seeing and inhabiting. With Handsome Jack and *TPS*, we see the inverse of this: the villains and Big Bad of the franchise become the focal point of our attention and empathy.

Beyond Jack — who is humanized through Athena's story of her involvement with him — *TPS* also develops existing villains and antiheroes in the Borderlands world as heroes, further scratching at the distinction between villain and hero. The four main playable characters in *TPS* are Wilhelm, the fearsome robot that almost destroyed the original Vault Hunters; Nisha, the Sheriff of Lynchwood, a notorious and difficult boss in *Borderlands 2*; Athena, an ex–Atlas assassin; and, of course, Claptrap, not a villain but a strongly despised character from the previous two games.

In an interview with video game website *Polygon*, Gearbox CEO Randy Pitchford explains how *TPS* humanizes some of

the franchise's most atrocious enemies: "You last experienced or encountered Wilhelm as the first boss that you fought, the first major boss you fought in *Borderlands 2*. He was a giant robot under the command of Handsome Jack. Wilhelm was once a man, and in the course, if you chose to play him, in the course of *Borderlands: The Pre-Sequel*, as you add skills, you will slowly transform him from a man to a machine. Every skill point you add increases the amount of cybernetic attachments and modification[s] that Wilhelm undergoes."[22]

In effect, by playing as Wilhelm in *TPS*, players are creating the mechanized monster they narratively fight later in *Borderlands 2*. It makes the player complicit in Wilhelm's descent into greater evil, showing the steps one takes to become a villain — and, importantly, how these steps are not at all different from the steps the heroes take in the two games before *The Pre-Sequel*.

Similarly, the gameplay of *TPS* shows us how Jack becomes a villain, and how the player characters are complicit in Hyperion's rise to power. Jack is the underdog in the story of *TPS*, the hero fighting against the evil Colonel Zarpadon — but he can only do that by claiming power for himself. Jack's sense of injustice drives him to action, and that same force carries the player characters: a sense of needing to protect, which requires more and more strength. In the world of Borderlands, strength always comes in the form of a more powerful weapon. For Jack, this weapon isn't a shotgun that can shoot swords (a gun only Torgue could dream up). Instead, it's the Vault and the monster inside it, the Warrior.

Before *TPS*, in *Borderlands 2*, bits and pieces of Jack's backstory showed us the complexities of his character. As a child, Jack was abused by his grandmother, whose care he was left in. In the *Borderlands 2* mission "To Grandmother's House We Go," Jack pays the Vault Hunters to go check in on his grandmother in the Eridium Blight, a toxic wasteland thanks to a Hyperion mining operation. The Vault Hunters find Jack's grandmother's cottage and, after fighting and killing all of the bandits there, discover his grandmother dead in her bed.

We hear Jack over the ECHO communicator. It initially sounds like he's crying, but that veneer quickly disappears: Jack is laughing. Relieved his grandmother is dead, Jack explains that he had hired the bandits to kill her. An eye for an eye, apparent revenge for the abuse he endured at her hands. Jack's retribution is seen as evil because it is in cold blood, decades after the fact, and she is defenseless. Jack's pain has crystallized into psychopathy, revealing him to be ruthless and calculating.

We learn that Jack comes from a place of trauma, but that the way he reconciles his hurt isn't to grow and forgive, but rather to take revenge — whatever he says is right and fair — and that becomes his guiding principle. He acts this way to the entire world around him, and especially in the way he rules at Hyperion and in Opportunity, the city he created.

In Opportunity, there are announcements made over the loudspeaker that boast of Jack's archetypal view of himself as savior. "Citizens of Opportunity!" Jack's voice says over the speaker. "You represent the beginning of a grand adventure. Opportunity is only the first Hyperion city on Pandora.

One day you'll be saying, 'Bandits? What's a bandit? I can't hear what you're saying over the motor of this free blowjob machine Handsome Jack gave all of us.'" Jack believes in what he's doing, not just as the right thing to do, but as the heroic path toward world peace.

At the end of *Borderlands 2* when Jack is defeated by the players, he shouts, "You idiots! The Warrior could have brought peace to this planet! No more dangerous creatures, no more bandits; Pandora — it would have been a paradise!" Since Pandora has never been a safe place for literally anybody, there's a certain logic to believing in Handsome Jack's promises. There comes a point, in every player's life in Borderlands, when they wonder if maybe Jack *is* actually the hero, after all. (No, of course he isn't, but that's the power of legend to mobilize and weaponize emotions.) Jack's villainy isn't neutral. He's not a morally ambiguous character, despite being a humanized one.

In 2016, *Deus Ex: Mankind Divided* attempted to be a game that doesn't "tell you what to think." The narrative designer on *Deus Ex: Mankind Divided*, Mary DeMarle, explained, "You have to make your own decisions. You live it. And we try to present all sides of that issue to you."[23] While seemingly noble on its surface, this attempt at neutrality in a game that is deeply political comes across as ambivalence, which alienates players rather than welcomes them.

Tanya DePass, founder of I Need Diverse Games, responded to DeMarle's comments with skepticism. "Well, I hate to remind you," DePass said, "but media does not exist in a vacuum. Games have different nuances & meaning for

me as a Black, queer via woman. Than it does for my white friends, or straight, or trans, or latinx, neuro divergent, etc. Media means a lot to different people."[24] For DePass, and for many marginalized individuals involved in video games, narrative neutrality isn't a noble goal; it's an act of erasure and upholding the status quo.

This is why the nuance given to Handsome Jack's characterization matters. Jack acts as a Big Bad for players to defeat and highlights this monstrosity in both ordinary people and heroes. Jack thinks he's the hero, but make no mistake about it: Borderlands knows Jack is a villain, a true monster, and doesn't hide it, even as it gives voice to his own delusions about himself. Jack's own history of being abused doesn't exempt him from taking responsibility for the horrific abuse he enacts on his own daughter, Angel.

Borderlands holds a mirror up to our real world, and comments on what it shows us. It has no interest in being neutral. When Borderlands wants to say something about the way our world works and the shitty things humans do to each other, it will say it. Loudly. And probably with air guitars and explosions and a fart joke or two. Jack is written to be understood, but not to be defended or sided with. He is heinous, and he is meant to be seen as heinous, but also as human — humans do awful, awful things.

Of all the ways George Lucas slights video games' potential for strong storytelling, him saying "you can't empathize with somebody you're going to kill"[25] most underestimates what video games do. While Jack is undeniably an evil character,

TPS and *Tales* portray Jack's psyche, motivation, and character with such humanity that it's impossible not to understand him. We see Jack motivated to protect Helios, the moonbase run by Hyperion. And we see him fall from grace as his true maniacal side comes out. When Jack reveals that the Eye of Helios (a laser weapon) is actually the eye of a mythic monster, Jack's struggle between hero and villain comes to its turning point. We feel this moment so strongly because of the way we saw Jack trying to be good — only to fulfill his inevitable heel turn. We understand his complexity and empathize, without losing the desire to beat him. And in this case, beating him means killing him. No matter the medium, a humanized villain whose motivations are clearly delineated makes for a more challenging and rewarding storytelling experience every time. Especially when, in Borderlands, Jack has the same motivation and goal as the protagonists: we're all trying to be the hero of a treasure hunt.

Borderlands shows how to create empathy for a villainous character without taking a false stance of moral neutrality. It lets you know Jack is evil, but still invites players to consider the nuance, the roots of his villainy, in a more complex discussion of the conflicts of our world.

Initially, Jack was designed as a thorough villain, written like the "jokepocalypse."[26] But Jack needed heart to be an interesting villain. If all he did was threaten the Vault Hunters and make jokes, he wouldn't be compelling. Jack's hero complex, drawn from legends, gave the character a depth not commonly believed possible in video games. Jack might be obnoxious, but he's believable.

In an article called "Lots of Games Are Morally Bankrupt, We Get It," Anthony Burch writes about the slippage between hero and foe in *Borderlands 2*: "Don't pretend you're something that you're not (a hero), but don't beat yourself up over your antiheroism — revel in it."[27] This embrace of ludonarrative dissonance is what makes playing Borderlands so spectacular. You don't have to accept that the game's core mechanic (murder) is at odds with the narrative's main goal (save people from being murdered) because the game forces you to think about it. Borderlands lets you in on its satire, points out its contradictions, and shows you how it plays with deeply ingrained cultural tropes. This ain't no place for a hero — but it's not supposed to be.

6

Fictional Worlds, Real People

Stories, regardless of the medium they are told in, have the ability to empower the people who consume them, especially if we can see ourselves in the characters. But video games have traditionally failed to include characters who represent our world's diversity.

The video game space was the first I came out in as queer. My gaming friends were some of the first around whom I felt comfortable acknowledging and accepting myself as bisexual. (Although I prefer the term queer for the way, for me on a personal level, it allows an acknowledgment of attraction beyond the gender binary.) Despite this, I still turned down the opportunity to be on a panel with other queer folks in games during World Pride in 2014 because I didn't think others would accept me as "queer enough." Hell, I still battle these feelings

and feel like I have to constantly prove my queerness. That's kind of fucked.

This is what the erasure of queer, racialized, non–gender normative, and disabled identities does. It makes people feel unvalued, nonexistent, and, personally, like I have to repeatedly tell myself my feelings, my attractions, my desires are all legitimate, regardless of how they are painted in mainstream media.

As a queer person who has had to battle a lot of negative opinions about bisexuality (including from people who dispute my sexual orientation as if they know it better than I do, as well as people who think bisexuality is not even really a thing at all, or a thing we should talk about), let me tell you: this can get tiring. As it is for anybody who experiences oppression, microaggressions, or other forms of prejudice, being an advocate for our existence — and our right to exist peacefully — isn't something we can just back away from. There are always people who just don't get it, and who won't shut up about the fact that they just don't get it. That's why finding mainstream media that *does* get it is one of the most relieving and wonderful experiences ever. It makes me downright ecstatic.

My frustration about the lack of representation is shared by many people of color, who also have a hard time finding themselves properly represented in games. In an article called "Video Games without People of Color Are Not Neutral," writer and games critic Sidney Fussell remarks on how white video game audiences decry the inclusion of people of color as being "political," holding the erroneous opinion that

games are otherwise "neutral" politically. Fussell writes, "The response from detractors was swift and vocal. They argued that adding non-white people to games in which they 'don't belong' (a common refrain for period fantasy) is pandering or illogical and would somehow taint, misrepresent, or destroy these worlds. Beneath the auspices of concern for accuracy, they're arguing that these are white worlds and can only function as long as they remain that way. And white worlds demand white heroes."[28]

Fussell takes to task detractors who argue that historical worlds are inaccurate if they include people of color, and rightfully so. As Tauriq Moosa writes on *Polygon*, "We are talking about being comfortable with the inclusion of wraiths and magic, but not the mere existence of people of color."[29] Falling back on this argument of neutrality and historical accuracy is whitewashing; it's bigoted and it's lazy, refusing to see the diversity of consumers and creators.

While Borderlands isn't the best example of a game that properly addresses racism, it does have a diversity of characters inhabiting Pandora, a heterogeneous mix of people. Each game allows players the option of selecting from four main playable characters (with the inclusion of two additional downloadable characters for both *Borderlands 2* and *TPS*). Players can choose from men of color (Roland, Salvador, Mordecai), women of color (Aurelia, Nisha), white women (Lilith, Athena, Maya, Gaige), a queer woman (Athena), a queer man (Axton), and an asexual woman (Maya). And while the NPCs of the world suffer from much less diversity,

playable characters with explicitly different identities mean a lot to those used to only seeing their identities stereotypically represented in the media they consume. There's a greater chance the characters will reflect the players, rather than just defaulting to cis-het straight able-bodied white dudes (such as Adam Jensen in *Deus Ex*, Nathan Drake in *Uncharted*, Isaac Clarke in *Dead Space*, Marcus Fenix in *Gears of War*, Master Chief in *Halo*, Doomguy in *Doom*, Joel in *The Last of Us*, Jack in *BioShock*, Booker DeWitt in *BioShock Infinite*, Duke Nukem in, um, well, *Duke Nukem*, and so forth). When asked about explicitly adding in gay or bisexual characters, the lead writer on *Borderlands 2*, Anthony Burch, said, "Why, why are these characters gay or bisexual? The answer is simple: we wanted to make our cast more diverse and inclusive, and it cost us effectively nothing to do so."[30]

Dead Island (2011), an FPS game about killing — you guessed it — zombies on an island, offers four playable characters but only one white man (Logan Carter). Your other options are Sam B., Xian Mei, and Purna, all people of color. These characters' backgrounds inform their playing styles and abilities, making their presence both welcoming to a diversity of players and an integrated part of the gameplay design. If you want to use ranged weapons, you have to play as Purna, and if you want to use melee and blades, you have to play as Xian Mei. This is less true with Borderlands: you don't learn the playable characters' backstories in the player select section, as you do in *Dead Island*, so you have to search online for what makes them different — or spend a massive amount of

time playing the game (as I have). But their playstyles dictate a similar selection process: if you want to play with siren powers (which are similar to mage powers), you have to play as either Lilith or Maya. You can't just map powers to any player; each offers a unique strength and way into the game, making each character equally valuable but distinct.

Queer characters are becoming ever more common in video games, thank god, and existed here and there before Borderlands. In Mass Effect, different NPCs are romanceable when you play as a man or a woman. But sometimes, your gender doesn't matter: certain characters are romantically and sexually into you either way. And that's super cool. One of my favorite video games of all time, *Fire Emblem Awakening* (2012), features a woman character by the name of Tharja, who is romantically obsessed with the player character, regardless of gender. And in 1998, *Fallout 2* included same-sex marriage; its developer Tim Caine explained that this was a non-issue for the game: "I don't even think anybody in the team really argued over it. We didn't think, 'Oh my god, this is an amazing thing.' It was just 'We're going to cover every possible base here.' And then we moved on."[31]

The cool thing about Borderlands? There's way more than just one queer character. There are *so* many.

There's Moxxi, a bisexual, polyamorous woman whose lovers and trysts are numerous. And I love Moxxi, but Moxxi is just the tip of the queer iceberg in the Borderlands world. *TPS* brings the most upfront, in-your-face, we're-not-backing-down attitude about the inclusion of queer characters with

Athena, who is the main character of the game's frame narrative, whether or not you select to play her.

A trained assassin now out for revenge, Athena teams up with the Vault Hunters to take down Atlas. In *Tales from the Borderlands*, we see what life post-merc looks like for her. She's settled down in Hollow Point with her girlfriend, Janey Springs. *Tales* does a lot of things right (its humor is on point — it features an entire shoot-out where everybody is just using their fingers posed as guns in the best and most ludicrous Western-style showdown in the history of video games; it has an incredible amount of heart; and it has a diverse cast of characters to play as and interact with), but one of the most important parts of *Tales* is the poignancy of Athena and Janey's relationship. They are a real couple, with the same ups and downs many couples have: they disagree, they have bumps, but ultimately they just *really* love each other.

We are first introduced to Janey Springs in *TPS*. She is the lovable mechanic residing on Elpis, one of the main NPCs who delivers important bits of information. If the character speaking to her is Nisha, Wilhelm, or Claptrap, Springs treats them all the same: nice but unimpressed. But if Athena is the one to speak to Springs, Janey immediately flirts with her. Which may not seem like a big deal on the surface, but trust me, it is.

Janey doesn't hit on just any woman. A common misconception about queer people is that we have no filter and just flirt with (and sleep with) whomever is closest to us. This should go without saying but, obviously, queer people

feel attraction the same way non-queer folks do, and Janey's changing reaction reflects this. And it's not that Nisha isn't attractive. Nisha is incredibly attractive (when Jack first learns about her, he makes a comment about whether or not she's single, and says maybe they should hook up). But Janey doesn't *find* her attractive.

It gets better, though. One of the earliest missions given out by Janey in *TPS* is to go kill some dude named Deadlift, the Elpis-equivalent of a bandit lord on Pandora. Janey explains that Deadlift has a key the player characters need in order to be able to digitally construct vehicles on Elpis. As in, this mission is critical for the rest of the game.

So, as the mission gets underway, the question is raised: why does Janey want Deadlift killed, instead of just, you know, asking the player to steal the key from him? Janey's response? "He's kind of a dick." Some player characters laugh at this and accept it, but others ask for more information. Either way, Janey explains a bit further: "Well, he also stole my Moon Zoomy digistruct key, stranded me out here, and got really rude when I told him I wasn't into guys. But mainly the being-a-dick thing."

During the events of this mission, Torgue comes over the ECHOnet every once in a while, shouting things in true Torgue fashion. When Janey explains that Deadlift was a dick to her about her being queer, Torgue shouts, "FRIENDZONE!" much to the collective eyeroll of every woman who's ever played a Borderlands game, I'm sure. But later, after the mission is completed, Torgue comes back over

the ECHO recording to clarify. Torgue, the parodic pinnacle of toxic masculinity, says, "I realize now that the friendzone is an imaginary misogynistic way of looking at relationships! You guys know what I mean?!"

Torgue. Torgue, the character who prioritizes explosions, kicking ass, and looking and acting like the most '80s action movie version of masculinity ever, calls out the friendzone and then drops the mic. And this is done in a story mission, a mission that *must* be played in order to complete the game. It isn't hidden away in a side quest people might not do. It's an integral mission, and the narrative that surrounds it is one designed specifically to counter misogynistic ways women — regardless of their sexual orientation — are treated. (The game came out in the same cultural climate as Gamergate, so it's no surprise that when angry dude gamers heard about this line, they got angrier.)

But regardless of predictable reactions, it's amazing that this bit of feminism is delivered, in part, by Torgue. *Torgue.*

I mean, in a way this should be no surprise, given that Torgue himself is bisexual. YEP. Borderlands doesn't just have beautiful, traditionally sexy women as queer characters. (It's worth noting here that Borderlands also includes a queer overweight woman named Motor Momma, who once dated Moxxi, furthering the idea that hey, not all queer women are skinny! I mean, Borderlands then screws this up by making Motor Momma cannibalistic and centering one of the few overweight characters they have on eating, which could be because she's a bandit and bandits *love* cannibalism, but still.)

Borderlands is also full of queer men characters, all of whom are strikingly different from each other. There's Torgue. There's Hammerlock, the Victorian-esque hunter who researches wild beasts and vicious monsters and acts as your wildlife tour guide on Pandora. There's Axton, the so-handsome-he's-boring playable character in *Borderlands 2*. Axton's queerness was initially a coding blooper in *Borderlands 2* that writer Anthony Burch just liked too much to not make canon. In the dev log on Gearbox Studios, Burch explains:

> Axton had some bi-curious dialog in the main game due to a slight hiccup in the writing process. Initially, I wrote a bunch of character-specific reviving dialog so that if you revived Sal[vador] while playing as Axton, he might say, "On your feet, soldier," but if you revived Maya, he'd say, "Woah — do you, uh, work out?" We didn't end up actually getting the character-specific code implemented but the lines all stayed in, so in the released game you can revive any male character and Axton still has a small chance to hit on him. After we mentioned this in an interview and some people on our forums expressed a bit of disappointment that he *wasn't* intentionally bisexual, I put some more overt dialog in *Tiny Tina's Assault on Dragon Keep* to confirm that, actually, yes — dude is bisexual.[32]

And there's way more. Tiny Tina is also queer, as she talks about having a crush on Maya and Moxxi (and it's also

amazing to see a young teen confidently know and assert her sexuality). There are also two queer couples in the Wildlife Exploitation Preserve level and there's Rose, an NPC in *TPS* who gives out a side mission. Queer characters are so common in Borderlands. Let me repeat this because it's worth it: in a first-person shooter that is defined as being over-the-top and replete with dark humor, toilet humor, slapstick comedy, and guns that shout at you relentlessly in high-pitched voices, there are *so many* queer characters that they begin to feel more like the rule and less like the exception.

And while I love all of this, Maya, the playable siren in *Borderlands 2*, is one of my favorite examples of positive representation in the franchise. Maya is gorgeous and the object of everyone's affections, including Tiny Tina and also Krieg, the playable psycho character whose love-at-first-sight feelings for Maya in part motivate him to try to overcome his grueling murderous and cannibalistic impulses. The wonderful thing about Maya is that she is asexual. Her asexuality comes out in small ways. Maya's only response to Tannis's intense attraction to her (we can add Tannis to the list of queer characters, as well) is "Huh, I'm attractive?" In the *Borderlands 2* DLC *Mad Moxxi and the Wedding Day Massacre*, there is a mission to give romantic advice to a robot (in the world of Borderlands, this kind of quest makes perfect sense). Maya's advice is: "I know almost nothing about romance, so please pretend I just said something really inspiring about the power of love," suggesting that she could also be aromantic.

These hints gesture toward Maya's lack of interest in

romance and herself as a sexual subject. Representation for asexuality just doesn't often happen in mainstream media (with a major notable exception being Netflix's animated show *BoJack* fucking *Horseman* [2014 onwards]). And rather than use her asexuality as her defining characterization, it's just simply a facet of her personality, there to flesh her out, in a subtle way that avoids feeling exploitative. It's there if you know what to look for, and for some people, this is everything. In "*Borderlands* & Asexual Representation: How I Discovered My Sexuality While Playing a First-Person Shooter" by Nico West for the *Mary Sue*, West talks about the hints to Maya's asexuality: "I found these instances to have nothing to do with so-called agenda pushing or tokenism, and instead considered them to add to the intricacies of Maya's characterization. It's strange, yet wonderful, that in such an over-the-top and cartoonish world that the characters that inhabit it are surprisingly human."[33]

West goes on to make an important point: "Of course, things become less funny when you realize that marginalized groups playing the game could potentially feel safer on a ruthless, dog-eat-dog planet like Pandora, where morality pretty much doesn't exist and violent anarchy reigns, than they do in their real life." And this is exactly why the wealth of LGBTQIA and racialized characters in Borderlands matters. Representation — good, nuanced, and diverse representation — lets us know that we are welcome.

West's article also highlights the fact that Maya's aesthetic (she wears makeup, doesn't hide her body) doesn't mean she's

sexual. In response to an anonymous comment about Maya's design, she notes that the way one dresses and presents doesn't equate to sexuality; it's limiting and potentially dangerous to think this way. Maya can dress and look however she wants, and people can feel toward her however they want, but this doesn't change Maya's sexual identity or anything about her.

Mikey Neumann, the chief creative "champion" at Gearbox, wrote a follow-up to West's post about Maya's asexuality that is remarkable. In his article "A Is for (A)Sexual," Neumann opens up about being asexual and what it means to him. Neumann writes, "And the rub of it all is the best representation I've seen of asexuality anywhere in the massive space that is consumable media, was in a game I wrote on, but didn't even think to do!"[34]

Another thing that I love about the queer characters in Borderlands is that, like the non-queer characters, none of them are romanceable. This game is *not* about hooking up in space à la Mass Effect, and it is not about hooking up with other characters to create stronger units à la *Fire Emblem Awakening*. It's a game about shooting people and looting treasure, through and through.

The queer characters in *Borderlands* are queer — simply because *that's who their characters are*. It's not a mechanic to get players to invest more in a certain character for their own romantic benefit. It's not a way of offering more "romantic choices" to a player, and it's not a gimmick. These queer characters exist simply because queer folks exist in the world. And gaming is finally catching up.

Anthony Burch wanted marginalized folks to feel welcome in *Borderlands 2*, and that extended to people of different abilities as well. In an accessibility review of *Borderlands 2* called "Blind Lady vs *Borderlands 2*" on her blog *Feminist Sonar*, Elsa S. Henry writes that while there are problems with the game for people with low vision, beating it — and enjoying it — is possible, especially if played in co-op with a trusted friend. Henry also remarks about how much she loves the customization in the game: "As of right now, my character wears an eye-patch over her right eye. Yes, that's right. I gave my character my disability. How empowering is THAT?"[35]

But even as *Borderlands* has made great strides in its inclusivity, it has stumbled into controversy in how it represents certain characters, like Tannis. In an article for *Polygon* called "Writing Characters, Not Symptoms: A Gamer with Autism Discusses What Our Hobby Gets Wrong," critic Joe Parlock talks about characters in video games that seem to align closely with traits and behaviors associated with autism — and how this largely fails people with autism. Parlock says, "While it's never explicitly said within the series that [Tannis] has autism, her personality and idiosyncrasies certainly hint at it. She is unsociable, struggles with showing empathy, and is very scientifically minded, all of which are fairly common traits of autism."[36]

For Parlock, Tannis's exhibition of behaviors associated with autism is a complex and largely frustrating experience. Parlock notes that it's good to see Tannis having agency, and that she is not just respected by others in the game, but that she serves a critical role in its events and victories. As Parlock explains,

"Tannis is her own woman with her motivations." It's the fact that she is so disliked by other characters that causes Parlock uneasiness with her possible representation of autism. Parlock writes, "While having disabled characters who are unlikable is important for reducing the tendency to treat characters with pity, in [Tannis's] case that dislike comes in traits that are seen as inherently autistic: unsociability and bluntness."

Tiny Tina, the very young explosives expert in Borderlands, also garnered some criticism. Tina is a pastiche of emotions and mannerisms, as her speech spans inner-city American slang, occasional British-isms, psycho-levels of violent speech, and speech patterns typical of little girls. For example, "Real badasses eat chocolate chip cookies, I'ma gonna get that tattooed across my back in Old English font." After the release of *Borderlands 2*, some critics called Tina's dialogue racist, citing when she appropriates words like "badonkadonk."

In a YouTube video called "Is Tiny Tina Racist?" games critic Ryoga Vee discusses how people reacted to Tiny Tina's vernacular as appropriation of language. Vee talks about the problem people have understanding how language believed to be used exclusively by Black people becomes merged with white people in America. "The answer is," Vee explains, "that it was never Black to begin with."[37] Vee takes this one step further by saying that Tiny Tina's speeches are "empty references that amount to nothing."

Tina Amini, writing for *Kotaku*, discusses a scene in *Assault on Dragon Keep* where racism gets discussed directly in the game. Tiny Tina makes all the dwarves in her game look

like Salvador, the playable Spanish character in *Borderlands 2*. Lilith gets frustrated with Tiny Tina, saying she can't make the dwarf characters all look the same, because that's racist. Tiny Tina gets defensive and asks Salvador if he thinks it's racist. Salvador gives it his stamp of approval, and Tina retorts, "BOOM. Not racist." Of course, this isn't actually an all-clear. Amini connected this scene to Burch's controversial depiction of Tina. Gearbox eventually clarified that the two were not related, that the scene was written before the accusations of racism were leveled at Burch. "At least it's interesting to see a video game character discuss racism at all in a game, however in passing or jokingly it may have been," Amini writes.[38]

Borderlands wouldn't be Borderlands if it wasn't at least trying to include some sort of critical commentary or tongue-in-cheek subversion of what we expect and what the cultural climate of video games is actually like. It doesn't always succeed, and at times it stumbles, falls, and starts a garbage fire.

When approached with concerns of Tiny Tina being racist, Burch responded with a willingness to change if he was wrong and a desire to listen. As a man of color, Burch was in the position to highlight diversity in *Borderlands 2*, and he responded to the Tiny Tina issue as we all should when challenged: by listening and being willing to learn. As Sidney Fussell writes on *Boing Boing*, "Privilege is blinding and allows us to ignore the many systems that keep certain groups of people isolated; 'historical accuracy' is just one example. When we speak of 'adding diversity' we must speak not just of characters but their consumers and creators."[39] As Fussell points out, and as

Burch has done, hiring diversely will also help make the stories we tell in video games that much better. Diversity behind the scenes on video games allows for different perspectives, ideas, and stories to be told and shared, making for better games.

At GDC in 2016, writer and narrative designer Meg Jayanth gave a talk, "10 Ways to Make Your Game More Diverse," in which she said, "Stories are suppressed because they are dangerous. Let's not fall into the trap of thinking that because diversity is a moral good that it is boring."[40] Borderlands proves that having fully developed, diverse characters makes for a game that isn't boring — it's fun, ridiculous, and endearing. It can be an FPS about fart jokes and still include a diverse cast of characters. In fact, it's better that way.

7

Sirens: "Fear Me, Bitches"

Without question, video games have a problem with how they represent women. I repeat: without question this is an issue. The fact that I can't even half-seriously, half-jokingly tweet that statement without getting random men in my mentions berating me, harassing me, proves that. And this problem is multifaceted. It comes in terms of visual representation (women characters almost always get overly sexualized in comparison to the men) and in their personalities and storylines (when they get written about at all). There have been outliers, of course, with Jo Dark in *Perfect Dark* (2000) and, more recently, the Mass Effect and Dragon Age games (2009–2014), which have been much better at properly representing women. But on a whole, video games victimize and sexually

objectify women characters and fail to do much else in terms of characterization.

In the article "What Did They *Do* to You?: Our Women Heroes Problem," video game critic Leigh Alexander says, "Our lead characters have to be hard, and while we accept a male hero with a five o'clock shadow and a bad attitude generally unquestioned, a woman seems to need a reason to be hard. Something had to have been done to her."[41] Alexander is writing in response to the 2013 reboot of the Tomb Raider franchise, where Lara Croft has a more realistic character design (she even gets to wear a winter jacket in the snow!), yet still can't escape the stereotypical way women characters are treated in video games. Rather than a storyline or a backstory that highlights her expertise, her capabilities, her knowledge, all of the qualities that would be noted in a male character, Lara Croft's "strength" as a character comes from trauma, a pain done to her to make her sympathetic. As Alexander says, "It seems that when you want to make a woman into a hero, you hurt her first. When you want to make a man into a hero, you hurt . . . also a woman first."

And this is why the sirens in the Borderlands world are important: their characterization allows them to be people and not just tropes. Sirens are more than just human: they're a little bit stronger, a little bit more powerful, and have very distinct tattoos running down one half of their body. Oh, and they're definitely only women.

The comic series *Borderlands: Origins* discusses Lilith's search for other sirens and her loneliness in explicit,

heartbreaking detail. Lilith is originally from Dionysus, a planet named after the Greek god of wine and madness. Lilith's arc isn't the pursuit of love, it isn't to reconcile some past trauma: she is searching for her sisters, the only other women in the world who can possibly understand her and explain just what the hell it means to be a siren. That search for a sisterhood is one that defines many women's lives, especially in male-dominated fields. That's a real story, a nuanced arc that is relatable and doesn't reduce Lilith to a character whose existence — and reason for existing — is predicated on male feelings.

In the comic, at the same time of her father's death, Lilith meets another siren — the first siren she ever meets — who tells Lilith who, and what, she is. Right before the elder siren dies, Lilith asks her, justifiably, what she is supposed to do now, as a child who lost her father and who she thought she was. In true prophetic fashion, the eldest siren says, "That is up to *you*. Do as you will and *grow* as you might. We siren have *no code*. We've only our *song*. It is *yours* to sing now." Lilith's reason for being in Pandora is to understand herself, and she just happens to kick a lot of ass along the way.

While the sirens of ancient mythology were dangerous seductresses of sailors, their function in Borderlands is the exact opposite. Throughout both *Borderlands 1* and *2*, Angel acts as a guardian angel, guiding the players through the treacherous maps, rather than leading them astray in order to destroy them. In all three games, but in *Borderlands 2* and in *TPS* particularly, Lilith acts as a guide, as well.

In *Borderlands 2*, Lilith is no longer a playable character, but is now an NPC doling out side missions and acting as the heart of the game's story. As she gives the player side missions to perform and complete, she's ever present over the ECHO recorder, offering advice, tips, and colorful commentary on the moral ambiguity of some of the missions (of say, letting a cult of psychos worship her and set themselves on fire in tribute to her, a fake god by the name of the Firehawk). In a world where both Angel (the main guide) and Roland (the main leader) are killed, Lilith takes the helm and becomes the new de facto leader of the Crimson Raiders against Handsome Jack and Hyperion. She is not the seductress, luring men away from safety: she is the leader, protector, and guide, ensuring that the Vault Hunters and inhabitants on Pandora are kept safe and allowed to live in relative peace.

Lilith was never afraid to take charge, to lead when she had to, and to step away when she had to. The sirens refuse to just sit back and do what they're told — especially if the person doing the telling is a man.

Another common victimization trope in video games is, of course, the damsel in distress, which positions women as objects: something to be saved and/or received as a reward, rather than as characters with subjective experiences and agency. In her article called "Bound Women: Why Games Are Better without a Damsel to Save," Claire Hosking aptly explains, "If you can replace a female character with an inanimate object and the game doesn't change, that's a good indication that the trope is in play and can be avoided. Heck, you

can just make the goal a physical thing rather than a female character who is forced to exist merely as a goal."[42]

Tiny Tina directly calls out the damsel trope by calling her bombs "damsels." Tina introduces the players to Mushy Snugglebites and Felicia Sexopants, her two bombs that have had their firepower stolen. Tina, literally, explodes stereotypes. After the player retrieves the bombs, Tina says, "Put a little bomb in the hot ass damsel, blow stuff up, and make people die." Tina's bombs are inanimate objects made to look like women, a direct middle finger to the way games so often treat women characters like inanimate objects meant to be saved.

But the humor doesn't make Borderlands immune to damsels in distress. While in *Borderlands 1*, Angel is an assertive, commanding guide, in *Borderlands 2*, she becomes, frustratingly, a woman character you need to save. And while, from the get-go, it seems as if Angel is going to be a stereotypical example of a damsel in distress, she retains her agency in her captivity, much like Lilith retains her agency when she is also imprisoned by Handsome Jack.

One of the first NPCs you encounter in *Borderlands 1*, Angel assists the Vault Hunters so that they can destroy The Destroyer and, though never on-screen, plays a critical role in ensuring the Vault Hunters are victorious. Until *Borderlands 2*, of course, when it becomes revealed that Angel is actually Handsome Jack's daughter, a double-double agent, helping the Vault Hunters but really helping Handsome Jack (but really she's actually still helping the Vault Hunters). In the second game, the Eridium released from the first Vault is being pumped into

Angel so she will charge the Vault key — against her will, by Jack. Jack and Angel's relationship is abusive, reducing Angel's characterization to the far-too-common "Who hurt you?" issue. Angel's morality is a bit gray throughout the games, but with her death, it's clear that her intentions were never evil, and she was just a puppet, controlled by her father and forced into helping his megalomaniac plots.

I have mixed feelings on Angel, and the role she occupies in *Borderlands 2*. Damseled and martyred, her death becomes the ultimate catalyst for Jack's breaking point (with her dying breath, she calls him an asshole), the moment he turns from the jokey asshole you love to hate to the hatred-fueled monster who will destroy the world. While in *Borderlands 1*, her role was to facilitate gameplay, to offer bits and pieces of narration and narrative cohesion, and to be a guardian figure for the players, in *Borderlands 2*, she becomes a character whose narrative existence is reduced to characterization fodder for a male character.

Luckily, this whole being-captured-by-Handsome-Jack device isn't the case for all the sirens. At the beginning of the game, if selected, Maya says, "Siren here. Nice to meet you all. If anyone tries to capture me, I'll incinerate their brain," a blatant middle finger to the way people — and male characters especially — are *constantly* trying to capture and control sirens (and, really, most women characters in video games).

Maya's statement isn't just idle character flavor: it's a very real threat. Sirens exist in a world that doesn't understand them but knows their power is something to be feared;

they live in a climate where people try to forcefully detain them and harness their powers. Throughout *Borderlands 2*, you encounter wanted posters for the four Vault Hunters. Salvador's $99,000,000,000.99 bounty is for murder, theft, arson, destruction of property, public indecency, cannibalism, trespassing, and profanity. Axton is wanted for war crimes (for a bounty of $5,000,000,000), and Zero is wanted for political assassination (for a bounty of $32,000,000,000). The bounty on Maya's head is valued at $720,000,000,000 — *considerably* more than the others — and the crime is simply being a siren. Because what is more threatening than a powerful woman?

In the *Borderlands 2* DLC *Sir Hammerlock vs. the Son of Crawmerax*, Maya says, "And that's why you never take orders. If I'm going to get blown up, I wanna get blown up for my own reasons." Maya, quite vocally, refuses to ever be damseled and refuses to ever lose her own agency, which is no small feat in a game that is constantly trying to control her kind and in an industry (video games) that is complacent at best and abusive at worst to women.

And this is what I love about the sirens: they're not just there to diversify the roster of strong dude, smart dude, and funny dude. The sirens are all distinct characters and, despite sharing a common legacy, feel like fully formed characters with their own identities. Which is also true for most of the women in Borderlands, including Moxxi and Ellie (more on them in the next chapter). The sirens are powerful. They're the game changers, the ones who everyone *wants* to control (or seduce) but who refuse to be taken (pun intended) and

refuse to lose their agency. Even when they are held captive, as with Lilith and Angel, they rebel, they fight back, and they absolutely dictate the terms of their rescue. In an industry where women standing up against inequality or harassment is met with more harassment, death and rape threats, and the potential loss of their jobs, women characters integral to the game and the game's mythos — to refuse to shut up, refuse to be pawns, and refuse to be sidelined — are something remarkable and worth celebrating.

As Lilith says, "With me around, you might just get somewhere."

8

Like Mother, Like Daughter: Moxxi and Ellie

I remember my first time entering the area in *Borderlands 2* called the Dust. I wasn't impressed. *Borderlands 1* was overwhelmed with browns and grays, and it was a bit depressing. But *Borderlands 2* took that same world and splattered it with a lot of paint. It's gorgeous, all sparkling ice, nauseating greens, and tantalizing purples. It is a game filled with color that makes the world pop, opens it up, and makes it beautiful — a world worth spending time in. And then there's the Dust — a barren place meant to evoke the American Wild West, home to bandits who have set up camps in a desolate area in hopes of remaining outside the law. Inhabited by the boisterous clan the Hodunks, the Dust is home to outcasts from more civil society — and in a place like Pandora, where bandits,

flesh-eating creatures, and all sorts of murderous mischief is the norm, that says a lot.

The Dust is also, importantly, home to Ellie. Ellie is the daughter of Mad Moxxi, the voluptuous, sensual, murderous vixen who runs a chain of bars across Pandora. Moxxi is, quite simply, the epitome of sex. She has gigantic boobs, an hourglass figure, a sultry voice, and a range of guns that all boast the best double entendres as names — Miss Moxxi's Good Touch, Miss Moxxi's Bad Touch, and, erm, Miss Moxxi's Crit. Moxxi stands as a subversive counterpoint to the traditional stereotypes of women in games. Borderlands as a franchise is a parody of its genre above all else, and its characters are no exception to this. Moxxi is the sexbomb woman character that exists in nearly every major video game franchise. She is gorgeous, she is sexy, and she is deadly and — on the surface — she is meant for male consumption.

But Moxxi is queer, a bisexual and polyamorous woman, and this part of her identity keeps her from becoming subsumed by the stereotype she is meant to parody. Never in the Borderlands franchise can Moxxi be romanced by the players. Despite Moxxi's sexualized representation, her sexuality and whom she chooses to bestow her affections upon are entirely up to her. Moxxi does what she wants, not what the players want her to do. It's worth pointing out that the player learns all of this from Moxxi herself, as she tells her stories and intimate details over an ECHO to the player character. At all times, Moxxi is in control not just of herself, but also how her story gets told.

Moxxi could and does date a playable character, Mordecai, but not while he is being controlled by a player. This difference is key: Moxxi's agency is entirely disconnected from the player's desires, so her character functions differently from the norm in video games (where women are usually sexualized objects for players to pursue, woo, and save).

Canonically, Moxxi refuses to be subjected to male desires or goals (unless, of course, she *also* wants what they're offering). In her backstory, it's explained that Moxxi was originally raising her family (Ellie and Ellie's brother, Scooter) as part of the Hodunk clan. Up until one of the Hodunks tried to make Ellie their clan wife, that is — an action for which Moxxi promptly murdered the clan leader before taking her family to live in the safety of Sanctuary.

The daughter of such a force to be reckoned with as Moxxi *has* to be something special, a force of nature on her own. And she is. But not in the way we might expect. Ellie is a stark contrast to her mom. Whereas Moxxi boasts a Barbie-like body with hips and breasts out of proportion with her waist, bright carnivalesque makeup that is this side of befitting a clown, and a sultry voice, Ellie is the exact opposite. Ellie is a fat woman, devoid of makeup, and clad in nondescript stained overalls — the uniform of choice for a mechanic who spends the majority of her time under cars and covered in dirt and dust.

But none of this makes Ellie less sexy. In fact, compounded with Ellie's brash and unapologetic confidence, Ellie is one of the sexiest — and most sexual — characters in the whole franchise. Ellie blatantly hits on the player character (regardless

of the character's gender, which allows for Ellie to be presented as bisexual). And Ellie doesn't just think she's sexy: she knows other people also find her sexy, an attitude that is rarely afforded to fat women characters, in any form of mainstream media but especially in video games.

The representation of fat characters in mainstream media is fraught at best, with so few positive exceptions that I can count them on one hand. (Sookie from *Gilmore Girls* is the only fat woman character in mainstream media that I can even think of as being portrayed as beautiful and capable, and who never once gets mocked for her weight.)

In the video "All the Slender Ladies," Anita Sarkeesian of *Feminist Frequency* says that "female characters across the board are often limited to that same specific body type," that is, the slender, humanoid, and conventionally attractive one.[43] Larger women characters in video games can also be counted on one hand. Ones that are treated compassionately are even rarer. *Saints Row IV*, developed by Volition in 2013, is one of the few games that lets players customize their avatar by body type. Typically, games let players customize their avatars from tall to short, to the exact placement of the chin, eyebrows, and cheekbones — but rarely are players given choice to play whatever type of body they want.

When Insomniac Games released *Sunset Overdrive* in 2014, game director Drew Murray was asked about the lack of body diversity by gaming website *Kotaku*: "We don't have many body types, but we do have men and women, stuff like putting beards on anybody, every skin shade under the sun,

the ability to dress the way you'd want if this apocalypse were to actually happen. Would I love to have 16 body types? Sure. But there's a point where you just have to make a choice, and we're doing so many things in this game."[44]

This industry prioritizes numerous types of beards over a range of body types. When push comes to shove and studios have to decide where to allocate their resources, inclusive body types don't make the cut. The message is that not only are fat bodies not worth the design effort, they simply don't have a place in video games.

Borderlands 2 takes that attitude, though, and skewers it: the bandits living in the Dust have created hood ornaments of Ellie to mock her. But rather than feel victimized or insulted by the hood ornaments, Ellie *loves them*. In the side mission "Positive Self Image," Ellie asks the player to go kill the bandits and reclaim these hood ornaments so she can decorate her garage with them. Of this mission, Todd Harper, a professor in game design at the University of Baltimore, says, "In the ultimate fuck you to her detractors, Ellie has them killed, and then surrounds herself with these tokens of scorn, which are 50% self-indulgent interior decorating and 50% visible warning."[45] Ellie reclaims objects meant to bully her, mock her, and deny her her sexuality and humanity, and she warns those who would cross her: she will murder you with her trash compactor.

In his article "Down to Size: *Borderlands 2*'s Ellie and Body Image," Aaron Gotzon writes about the importance of reclamation in movements that oppose systemic oppression, like

fat pride: "The game lets us make the inference, justified by dialogue and exposition, that Ellie's achieved inner strength already. She doesn't *need* the player to affirm her worth. The player's not the point, not the center of the action in this case. This reclamation isn't a last stand, isn't grasping at a verbal straw from the hand of power. Instead, it's a symbol of what's *already* been achieved."[46]

Just like Moxxi doesn't need the player to dictate her romantic and sexual relationships, Ellie doesn't need the player to affirm for her how sexy she is. Both Moxxi and Ellie represent women characters who exist in a world (and an industry) that is dominated by fatphobia and misogyny, and yet they don't exist *for* this world. They continue being sexy, independent, and unapologetic no matter what a player does or says or thinks. Quite simply, there is nothing a misogynistic or fatphobic player can do that will take away either Moxxi's or Ellie's pride, strength, or value.

In *Borderlands 2*'s most well-regarded DLC, *Tiny Tina's Assault on Dragon Keep*, Ellie offers another charming and body-positive mission to the player. She asks the player to get her armor, "something to protect her beautiful girth." After the player finds some armor abandoned in a tree, Ellie is dismayed to learn it's nothing more than a metal bikini: "That ain't armor. Have you seen me? That little scrap wouldn't even cover half a tit. 'Sides, it ain't like the bad guys are only gonna aim for my saucy bits." Ellie is unapologetic about her weight, and never misses a chance to sexualize herself. (She also so

perfectly and effortlessly calls out the sexism and absurdity of stereotypical armor for women.)

The player then finds armor that is *actually* armor that is "sturdy and protective (like armor, you know, should be)." The player is given the option of giving Ellie either the metal bikini or the sturdy armor. This decision is important because it forces the player to choose to either consent to Ellie's wishes or reinforce a sexist trope. What's amazing, though, is even if the player chooses the bikini, Ellie *still* acknowledges how fabulous she looks it in, defying anybody who would use this opportunity to mock her.

The reward for completing the mission and giving Ellie the sturdy armor is a shield, a reward befiting someone who values actual protection over sexist tradition. The tagline for finishing this mission is "Sticks and stones may break her bones, but orcs will never hurt her." Playing on the traditional rhyme meant to inspire kids to not let the mean things bullies say get them down, this line gives all the power to Ellie, acknowledging the inherent lie in the original children's rhyme: words *do* hurt. But Ellie won't stand for this.

Fat bodies tend to be treated as undesirable and unsexual, and as something to be mocked. But Ellie stands as a beacon against this, with *Borderlands 2* including her as an empowered, sexual character. And that's refreshing, especially in a world so filled with fatphobia that misconceptions about health and weight are not just abundant, but shared widely as fact. We need fat bodies to be portrayed as sexy, both in and out of

video games, because fat shaming accomplishes nothing aside from perpetuating harmful stereotypes.

Indeed, Ellie pushes back against her mother's fat shaming, leaving Sanctuary because Moxxi won't stop insisting she lose weight in order to attract a husband. Ellie has no interest in losing weight, because she's happy, confident, successful, and sexy exactly how she is. Upon completion of the armor mission, Ellie shouts, "Feminism, baby! Woo woo! Hot damn, do I look good" — it's an empowering moment. Players could mock Ellie for this, but Ellie would just wink at them. She knows she's sexy, and she doesn't give a damn about what anybody else has to say that about that.

And that's not just incredible. That's unprecedented in video games.

9

"Called Me Mad, They Did":
Madness, Survival, and Psychos

When I was doing my MA, I became enthralled with Michael Ondaatje's prose poetry collection *The Collected Works of Billy the Kid*. What struck me the most about it was the way it seemed to talk about madness as a sort of survivalist technique in the Wild West. How else do you survive unthinkable violence and unspeakable odds? Losing some semblance of your sanity seemed like an okay idea, if it helped numb you to *some* of the realities you were facing. Ondaatje writes, "where bodies are mindless as paper flowers you dont feed / or give to drink / that is why I can watch the stomach of clocks / shift their wheels and pins into each other / and emerge living, for hours." Ondaatje positions Billy as only able to survive both the violence *and* the mundanity — the lack of food, water, adequate shelter, the loneliness — of the Wild West by being

mindless, a sort of disconnected, disassociated state of madness. Maybe this is part of why I fell in love with Borderlands immediately. With the most iconic enemy being the psycho, and a lawless setting meant to evoke the Wild West, *Borderlands 1* reminded me of the most moving work I'd encountered in my academic career.

For *IGN*, critic Rick Lane writes, "Games can use madness to many other ends than creating a clever plot or compelling character. It can form part of a mechanic to affect how players experience the virtual world around them, to toy with their expectations. It can also be used to explore, criticize, and confront some of the readily accepted genre conventions which many games adhere to."[47] Especially in the context of shooters, NPCs who are mentally unstable would logically populate such violent worlds, revealing the cost for those who live in the turmoil that constant shooting, murder, and mayhem breed. These are not the mercenaries, trained to do what they must to survive; these are the civilians, the collateral damage in a hostile environment.

Madness and survival are inextricably linked in Borderlands. In the beginning, there is Tannis: a brilliant scientist who, after watching her colleagues be brutally murdered (one even on top of her) and pursuing the Vault for too long, loses her sanity. But her delusional state provides the means for Tannis's survival. She has imagined conversations with her mother, which further her scientific thinking and allow her to work through problems. Tannis enters into a dramatic, on again, off again relationship with her ECHO recorder, which

eases her isolation and loneliness. While played for laughs, it struck a chord in me: Tannis is only able to survive the harsh violence of Pandora by forfeiting her sanity, a cruel fate for a scientist who prides herself on her objectivity and intelligence.

There's also Rabid Adams, a lunatic (which are renamed "psychos" in *TPS*), holed up in a bunker on Elpis. (Like with the naming of a few of the enemy types, I feel incredibly uncomfortable at the use of the names "psychos," "lunatics," and "midgets" for particular enemy types. As critic Parlock says in his article on autistic representation, "Gearbox comes across as very confused with how to portray disabled people.") Rabid Adams hid himself and his treasure away, sealing himself off behind two giant steel girders positioned in an X, with only ECHO recordings scattered across Elpis as a guide to where he was located. Madness and archives seem to go hand in hand in the world of Borderlands: Rabid Adams created a treasure map leading back to where he hid himself — in case he got lost. But as he remained isolated in his treasure trove, he began to slip into delusions and hosted conversations with imaginary people, much like Tannis before him. "Called me mad, they did," Rabid Adams said over his ECHO. "But I'm the one still alive."

Apart from the more tragically rendered depictions of Tannis and Rabid Adams are the psychos, bandits driven insane by their obsession with the Vault (an arguable future for Handsome Jack and anybody else who takes obsession with the Vault to Gollum levels). Psychos make up a large portion of the enemies in the Borderlands games. The psychos shout

wonderful things, mostly concerning dismemberment and cannibalism (sarcasm definitely intended). And their origins reside in madness as an environmental hazard of the Vault. Many of the convict workers at Dahl's Headstone Mine began to lose their minds from too close proximity to the Vault and became the psychos of Pandora, marked by their trademark masks with an upside down *V*. Some of the convict workers even became physically mutated, becoming larger-than-life parodies of masculinity or stunted in size and growth.

In a review of *Borderlands 2* for *Time*, writer Jared Newman remarks on the sympathy he felt for one of the incredibly problematically named enemy types, "midgets." Of this remorse, Newman writes:

> Though I rarely feel remorse for video game villains, something about the death of one particular Psycho Midget got to me. Hidden behind a corner, I could only hear his high-pitched squeals ("So cold! So cold!" as he bled out). These are the same type of foes who get strapped onto larger enemies' shields to serve as extra padding, and at one point, I freed one by killing the brute first. But then, in a moment of panic, I shot the midget dead during his freedom celebration, fearing he'd come after me next. These guys just can't catch a break, and it's really all my fault.[48]

What I find interesting about Newman's reaction is the way the enemy's humanity is able to move him, despite his player's

imperative to kill psychos, even if they are being mistreated by the other bandits. Newman's remorse at hearing the dying enemy say, "So cold!" could be because of our tendency to infantilize shorter characters, but it could also be because we are *supposed* to see the psychos as less sane Vault Hunters — and empathize. However, the morality of focusing a game's mechanic on killing characters who have lost their minds is questionable, as in *Batman: Arkham City* (2011). (In *Arkham City*, Gotham is overrun by Batman's typical rogues gallery, but also by escaped patients from Arkham Asylum, the mental institution of Gotham, whom Batman must fight.) Never mind that mentally ill patients are more likely to be victims of violence than perpetrators of it, using mentally ill people as nameless enemies to beat up on is tired, overused, and unimaginative. Even when used to subvert traditional notions of heroism.

In *Borderlands 1*, the bandits and psychos frequently shout at the Vault Hunters, "You never should have come here!" and they're right. As the player characters, we are invading their territory, participating in a colonial narrative. We are murdering them. And just as the "good guys" aren't so good in Borderlands, the psychos aren't always evil. Well, they're not always bad. Well, they're maybe a bit more morally ambiguous than other enemies in other video games.

Borderlands 2 boasts a large cast of friendly NPC psychos. These characters more effectively humanize the enemy because they have agency and personality; they are not just murder fodder for a player to mindlessly kill. Incinerator

Clayton is one of the, er, more friendly psychos in the game. The leader of the Lilith-worshipping cult Children of the Firehawk, Clayton provides missions mostly revolving around ways to keep the Firehawk happy (which mostly means setting cult members on fire). Other notable psychos are Face McShooty, a non-hostile psycho who doesn't attack the player; he instead asks to be shot in the face. Then there's Flesh-Stick, the psycho believed to be responsible for the death of Tiny Tina's parents. These characters show how madness works with violence to form the basis for survival on Pandora, and they do so in a way that grants them agency.

But of all the psychos, the most humanized is undeniably Krieg.

Krieg is unforgettable. He's a playable character, but only available via DLC for *Borderlands 2*. While it's never explicitly stated what turned Krieg into the lumbering human meat–obsessed psycho that he is, it's reasonable to assume it's Vault-related; his backstory implies he may have been a Vault Hunter. With its typical twisted sense of humor, Borderlands tries to humanize Krieg and, by extension, all of the psychos. In the trailer reveal for Krieg, we see that Krieg's psyche is divided: there is his outward presentation — a mutated, fearsome psycho wielding a buzzsaw and capable only of shouting about how much he loves meat and human feces — and then there is his internal monologue — a frighteningly coherent voice that narrates his imprisoned thoughts and desires. Krieg only kills those who deserve it, *Dexter*-style, and his interior monologue reveals his past helping people and getting

paid with loot, just like a Vault Hunter on the main quest in Borderlands.

His imprisoned voice provides an interesting caveat about his actions: if Krieg ever kills an innocent person, the voice will force Krieg to kill them both — the voice *and* Krieg — as punishment. At the end of his debut trailer, which is endearingly named "A Meat Bicycle Built for Two," Krieg saves Maya's life, and Maya recognizes that he saved her and spares his life. It's a moment of hope: perhaps one day the voice inside Krieg will be able to exert more control on his outward self, and he could become the hero that he feels he is.

Fans have theorized that Krieg is Tiny Tina's father, who is presumed dead. While discounted by the minds behind Borderlands, this theory still holds the hearts of many fans because it allows for the possibility of hope, redemption, and an adorably bizarre family reunion (Krieg with his love of axes and Tina with her love of blowing things up). The grip of this theory also indicates how deeply humanized Krieg is for the fans. Who wouldn't want to see the joyful reunion of Tina and Krieg, which would likely result in the deaths of many, many, many bandits?

So, yes, the naming and the treatment of the psychos in Borderlands make me uneasy, but with Krieg, I too feel a little hope. Krieg helps Borderlands humanize the psychos, to show them as more than just crazed cannibals and vicious murderers, to give them agency in a twisted Borderlands way. I mean, Krieg is still violent, but his motives are more nuanced, and who in the game *isn't* supremely violent? He wants to

help; he's just trapped within himself and cannot overcome this disconnect.

In *The Collected Works of Billy the Kid*, Ondaatje portrays violence as calculated, never ruthless, and almost always necessary — much the same way *Borderlands 2*'s Zero approaches his kills, as he speaks in haiku while viciously murdering bandits. In a world that offers you no hope, no ethically sound decisions, and no way of protecting yourself, your loved ones, or your future save for brute force and a well-stocked cache of weapons, what other choice is there? Pandora, like the Wild West of Billy the Kid, shows us a world where letting go of sanity and embracing extreme violence isn't necessarily inhuman, but a coping mechanism.

It is a skag-eat-skag world out there, after all.

10

Forgiveness, Death, and Mourning

For a medium that so heavily deals with death, video games so rarely actually talk *about* death. Notable exceptions are few and far between: *Planetfall* (1983) had players experience the NPC robot Floyd's unexpected death, and *Final Fantasy VII* (1997) forced players to deal with the death of Aeris, an active member of their team. And while the deaths of video game characters have affected players, games rarely look at death as anything more than a mechanic or a quick narrative punch. As game developer Gabby DaRienzo says, "In video games, death can serve multiple mechanical roles — it is most commonly used as a thing you want to avoid, a goal you need to accomplish, or as a narrative device. While death is prominent in many video games, we generally give it much less thought and

treat it with much less seriousness than actual death, especially when it comes to player death."[49]

Player death is sort of a joke in Borderlands. Many games ignore respawns (when your player character is "brought back to life" after having died) and don't integrate them into the game's narrative. You'll just start again at your most recent save or checkpoint and continue on your merry way. But Borderlands uses respawns as an opportunity for satire. After dying, the player character is reconstructed digitally at a New-U-Station, which stores a character's DNA so that they can be reconstructed anytime after death — for a fee, obviously. And each respawn is met with a cheeky comment about your most recent death, such as the existentially terrifying "Hyperion suggests that you do not think about the fact that this is only a digital reconstruction of your original body, which died the first time you respawned. Do NOT think about this!" or the more blasé "So, how was dying?" Death is a matter of mechanical course in an FPS game, and so Borderlands pokes fun at the convention and how easy it is to respawn.

For Borderlands, death is often a joke. In *Borderlands 1*, TK Baha is an NPC who, after giving the player a few missions, is killed by bandits. TK Baha's death comes early in the game and sets the tone of danger and violence on Pandora. But that isn't the last of TK Baha. In the DLC for *Borderlands 1* called *The Zombie Island of Dr. Ned*, TK Baha reappears as Zombie TK Baha, giving out missions to the Vault Hunters once again. These missions include: "Brains" and then

"Braaains" and so forth until brains has 17 *A*s. So, not exactly the most serious treatment of death.

In *Borderlands 2*'s DLC *Captain Scarlett and Her Pirate's Booty*, death is used not for a satirical take on gameplay conventions or as a silly joke, but instead in extremely dark comedy. Shade is the sole surviving resident of Oasis, a desert map on Pandora totally devoid of water. The way Shade mourns, though, isn't what you would expect. Instead of leaving Oasis behind, Shade remains — and rigs up the corpses of his deceased friends, acquaintances, and foes all around Oasis so that he feels a bit less lonely. Shade also places ECHO recorders near the bodies so he can pretend to have conversations with them. His loss of sanity is likely from extreme dehydration and loneliness. One mission Shade gives to the players is to propose to a woman Shade loves (she's dead, don't forget). So, the Vault Hunter finds the corpse and interacts with the ECHO recording left there to act as her voice. When the Vault Hunter tells the corpse of Shade's marriage proposal, she declines. Or rather Shade, recorded in her voice, declines his own marriage proposal. Sad, funny, and uncomfortable, it takes an approach to grief rarely investigated.

Then there's *Tiny Tina's Assault on Dragon Keep*, a DLC that offers such a heartwarming and heart-wrenching depiction of grief that it still makes me cry when I play it. While Shade's mission is a depressing look at a failure to mourn, *Tiny Tina* explores how we can use forgiveness to accept death.

Tiny Tina's Assault on Dragon Keep is devoted entirely to

Tina mourning Roland, a father figure to her. In *Borderlands 2*, Roland explains that Tina is an old friend of his: "I've saved her life a few times, and she has saved mine more times than I can count." Roland is a friend who has stood by Tina, who respects and cares for her.

In *Assault on Dragon Keep*, Tina is the dungeon master in a game of *Bunkers and Badasses* (Pandora's version of *Dungeons and Dragons*) for the living Vault Hunters, Lilith, Mordecai, and Brick. While they're ready to begin the game (which narratively occurs after the events of *Borderlands 2*), Tina insists they wait for Roland. Who is never going to show up, since Handsome Jack murdered him. On the surface, the main quest in the Vault Hunters' game of *Bunkers and Badasses* is to find a new queen, defeat an evil sorcerer, and restore peace throughout the land. But really it's just about Tina grappling with the loss of Roland. As the game progresses, Lilith, Mordecai, and Brick humor Tina whenever she says they have to wait for Roland, knowing he will never show up.

It's a rarity for the impact of a character's death to be given such a nuanced exploration as it is in *Assault on Dragon Keep*, especially in an FPS. A focus on empathy in games is rising in critical and popular success. Notably, *Life Is Strange* (2015), the point-and-click game about a teenage girl able to rewind time to try to solve the mystery of a girl's disappearance, is lauded for its empathy and tackles teen bullying, suicide, and queer relationships in a well-handled and honest way (even if it does include cheesy dialogue that definitely feels written by adults, like "Go fuck yourselfie"). Borderlands — and *Tiny*

Tina's Assault on Dragon Keep specifically — explores grief and mourning in a way that creates empathetic connections within the fictional world of the narrative, as well as between the player and the characters, thanks to its more realistic portrayal of the aftereffects of death.

But there's more to this than just mourning and coping with grief. Lilith's care for Tiny Tina also demonstrates how Lilith navigates her own healing and forgiveness, especially toward Angel, who was in part responsible for Roland's death. Lilith defends Angel to Tina — a big deal for Lilith, who is grieving her boyfriend, partner, and friend.

It's moving to see the way Borderlands introduces forgiveness and mourning into the narrative aspects of the games. Angel's death shows how evil Jack is, but also how Lilith forgives the events leading up to Roland's death, and her own part in those events. Tina's history doesn't just make her an adorably dynamic character, it shows how difficult mourning still can be in a place where people you love could be murdered any day.

This nuanced and loving look at mourning isn't afraid to tackle the uncomfortable truths about what it's like to miss someone, to know they are gone forever. Borderlands resists relying solely on satire with the New-U-Stations or uncomfortable dark humor, but explores the truth of mourning through Tiny Tina: the hurt, the struggle to accept loss, and the importance of community when grieving. The deaths of NPCs don't often get talked about within a game, and mourning is rarely the focus of missions or gameplay. In

Assault on Dragon Keep, mourning drives all of the action: we can't just forget Roland's death; alongside Tina, we have to go through the weird ways we forgive, mourn, and slowly learn how to move on.

11

"My Siren's Name Is Brick, and She Is the Prettiest": Toxic Masculinity

It's impossible to talk about Borderlands without addressing the most obvious part of it: it is a riff on a first-person shooter, and first-person shooters are notorious for their ridiculous commitment to the space marine character (that is, *so many* first-person shooters feature protagonists who are cardboard copies of the same ruthless and very, very, very muscled soldier). Think every Gears of War (2006–2016) game. Video games are guilty of pandering to and supporting toxic masculinity, the socially constructed stereotype of men as violent and unemotional. With these characteristics established as the norm, the space marine only serves to perpetuate harmful standards for men. To be strong, to be the hero, you have to be these "manly" things.

And Borderlands knows this. Oh, does it ever. No satire of the FPS genre would be complete without a completely silly undermining of this machismo, and Borderlands takes toxic masculinity and challenges it (while also poking fun at it).

For *Playboy*, games critic and journalist Carli Velocci wrote about the way masculinity is portrayed in *Tales from the Borderlands*:

> Rhys and Vaughn, [*Tales'*] two male heroes . . . They're not masculine, according to society's terms. The people who get promotions and get ahead at Hyperion are those like . . . the villain Handsome Jack — ruthless, sociopathic killers with narrow goals who engage in violence without a second thought . . . Rhys, while starting off the game wanting to be like Handsome Jack, can't handle the responsibility. Jack, Vasquez, and other characters see him as a wimp. Even with having Handsome Jack in his head giving him advice, he often becomes the victim of physical or verbal abuse and can't follow down the same path.[50]

Velocci nails what makes Rhys such a great character: he flips the script on the usual video game power fantasies. He's not a space marine or a super smart (but also super strong) guy like Adam Jensen in *Deus Ex: Human Revolution*. He gets made fun of *constantly*. But despite this — or in spite of it — Rhys *is* the hero. He rises above the bullying, the comments that he can't save his friends or Pandora, the stereotype that he is not

masculine, and he does what every video game hero does: he saves the day.

The thing is, though, this type of subversion isn't just found in *Tales*. From the very get-go, *Borderlands 1* establishes itself as a tongue-in-cheek romp through the stereotypes of masculinity that abound in video games. Roland is the typical hero: he's compassionate, strong-willed, understanding, and very, very good at what he does. He's the ex–military soldier now working to protect the people he previously terrorized under martial law. Hell, he even gets the girl, as *Borderlands 2* has Roland and Lilith develop an endearingly awkward relationship.

But Roland is different. First off, he's a Black protagonist voiced by a Black voice actor, a frustratingly uncommon occurrence in the world of video games. He also gets kidnapped — a rarity for male protagonists — making *him* the so-called damsel in the first rescue mission of *Borderlands 2*. If you'd never played *Borderlands 1*, you'd meet Roland while rescuing him from a Hyperion holding cell, where he is still giving orders and being generally badass. Roland plays as the typical hero character: he's strong, but he's also a good guy, and his earnestness is contrasted with satirical and ridiculous characters like Brick and Wilhelm.

The character of Wilhelm — a fearsome robot in *Borderlands 2*, but still a cyborg in *TPS* — explores the idea of mechanized masculinity, fairly common in both action movies and video games. Pinnacles of masculinity are men who are like machines. James Bond's movements are methodical, and his gun works more like an extension of his physical body than a separate

object. In the video game *Deus Ex: Human Revolution*, the protagonist Adam Jensen augments his body with literal machines in order to become stronger, faster, and smarter. In *Tales from the Borderlands*, Rhys has a cybernetic eye and hand, giving him the edge he needs to become the underdog hero. Mechanized masculine bodies are par for the course when looking at what makes an efficient mercenary or hero.

While many of these characters remain human despite their mechanized extensions or augmentations, Wilhelm takes this further: he becomes a literal robot, an enemy and a villain when he is fully mechanized. While meant to be terrifying, it's also one of Borderlands' winks at the absurdity of this idea: Wilhelm took the metaphor so far as to not make it a metaphor anymore.

If Roland is the earnest good guy hero and Wilhelm the overpowered counterpoint, Brick is a combination of them both: he's ridiculous, over-the-top, and exactly what you would expect to find in a video game, but he's also sweet and compassionate, whether or not his burps smell of blood.

In *Borderlands 1*, player characters are introduced by their archetypal roles (soldier, hunter, etc.), but Brick is "himself." Brick isn't an archetype inasmuch as he is a caricature of the "strong man." (And he is the prettiest.) He's the berserker character, meaning he uses guns, but only when he cannot use his fists. His skill is to put away his guns and let you go nuts punching as many enemies as you possibly can. Which is great. It's *so much fun*. Brick makes uncomfortable grunting and gurgling sounds as he punches people, and it's

weirdly wonderful. (I believe the exact quote is, "UWULR HUWURR UWAARRRLARLRRLWAA!" Or I might be confusing it with "RAAGH! KILL!" Who knows, though.) But he's a lot more than silly fun with murderous fists of rage. He's such a wonderfully sweet character who punches stereotypes of toxic masculinity until they explode in an over-the-top mess. He's a direct subversion of this genre's giant mercenary stock character.

On the surface, Brick reads like he'll be as stereotypical as ever. Brick's a berserker who formed a gang called the Slab gang, which you encounter in *Borderlands 2* in maybe my favorite map ever, Thousand Cuts (which includes places like "Broke Face Bridge" and "Bloody Knuckle Point"). Brick's size and strength are so staggering that he doesn't *need* weapons to take down Hyperion war robots. Because sometimes his punches also cause explosions. In the DLC for *Borderlands 1* called *Miss Moxxi's Underdome*, it's revealed that Brick's mother was also a good fighter and had made it pretty far in the Circle of Slaughter there as well, further proving that in Borderlands, awesomeness is passed down by the mother.

Throughout the course of the games and the comics, Brick's intensity and insistence on his innate personal strength are literally played for laughs, rather than just being there for their epicness. He's violent, yes, but that violence is exaggerated, it is comedic, and it is borderline sociopathic. It is not a power fantasy to be thoroughly inhabited. It's a power fantasy to have fun with and to poke fun at.

In the *Borderlands: Tannis and the Vault* comic, Brick, along

with the other Vault Hunters, squares off against Sledge, another comical caricature of macho men in video games. As they fight, Sledge shouts, "No! Only Sledge may wield a weapon in the duel of sweaty masculine man fighting!" with true Borderlands tongue-in-cheekiness. Brick's response to Sledge is, of course, "What do you bet that one of us falls out of here punched to death?"

Punched. To. Death.

That level of silliness is only on par with the first Predator movie, where Carl Weathers and Arnold Schwarzenegger's endearing high five turns into a legitimate arm wrestling competition.

The comic gives Brick's silliness a lot of room to shine, with such great one-liners as "Go! I'll punch cover for you!" When Lilith warns the Vault Hunters to be quiet, Brick responds, "I'll punch their skulls out . . . quietly." Brick's zeal in punching is adorable. Actually adorable, rather than inherently threatening. And that's the point, to show how ludicrous toxic masculinity is when played out and realized in a three-dimensional character. Because Brick isn't just a satire of machismo. He's also earnest about his emotions and unafraid of femininity. In *Tiny Tina's Assault on Dragon Keep*, Brick wants to play *Bunkers and Badasses* as a siren: "My siren's name is Brick, and she is the prettiest." He then proceeds to punch everything in the game, even when he should be talking.

Brick's interactions with Tina provide some of the best lines of dialogue, in both *Borderlands 2* and *TPS*. In *TPS*, when you encounter Deadlift (whom Janey enlists you to kill for

being a dick), Brick remarks upon Deadlift's style with awe by saying, "This dude's awesome." Tina's response? "You boys and your cool spacesuits and your muscles. You think you're strong. I can take you. TICKLE ATTACK!" Tina then engages Brick in a ferociously cute tickle attack battle, with Brick saying, "Ha ha, c'mon Tina. Now stop! Stop — Tina! Tina, stop it! STOP IT, TINA!" With all pretense of seriousness now gone, Tina shouts, "I WILL OBLITERATE YOU!"

This exchange, beyond being delightful, reveals the heart within Brick; his interactions with Tina reveal a softer side to him. Considering *Tiny Tina's Assault on Dragon Keep* is an entire DLC dedicated to the adults nurturing Tina as she mourns Roland, the camaraderie between Brick and Tina shows how he is capable, and willing, to take care of her, alongside the other Vault Hunters, like a family. They fight together. They win together. They also grieve together. None of them — Brick included — is a lone wolf, a hero squaring off solo against their nemesis in an individualistic battle for glory. So much so that the game is often considered best played co-op, and the vehicles are designed for three players to share together.

And in any family unit, there's always that one peripheral cousin who is just a little stranger than everyone else, but loved nonetheless. Here that person is Torgue. No conversation around machismo and subversion of masculine tropes would be complete without talking about the Macho Man parody himself, Mr. Torgue High-Five Flexington. (And yes, that is his real name. In fact, Mr. Torgue is his first name, as revealed in *Tiny Tina's Assault on Dragon Keep*. If you haven't

caught on yet, *Tiny Tina's Assault on Dragon Keep* is the most endearing and wonderful DLC, for Borderlands absolutely, but also probably for any other game.) If you use a Torgue vending machine (which sells ammo, so it's likely you will at one point), you have the random chance of being greeted with a shout of "TESTOSTERONE!"

(Speaking of wonderful randomly encountered lines on the theme of masculinity: if you gunzerk as Salvador, he will sometimes shout, "Time to compensate!" and "Screw you, Freud!")

Torgue is the CEO of the weapons manufacturer Torgue (yep), which focuses on explosions and how explosions prove your manliness. In the official Borderlands guide, the Torgue sales pitch reads: "The next time you go shopping for a new gun, ask yourself one question: Are you a man? If you answer in the affirmative, then you're ready for a Torgue. You see, we at Torgue make guns for real men. Tough guys. Badasses. The kind of guys your dad was and you hope to be!"

From the very get-go, Torgue — and all things affiliated with Torgue — directly focuses on the idea of what constitutes a man. If Brick represents the machismo of typical video game heroes, Torgue takes this and amps it up to 11. Torgue was born with facial hair and glistening pecs, and his affinity for explosions born from a desire to understand and tame the force that claimed his parents, who were killed in an Eridium mine explosion.

Borderlands 2 saw Torgue get his own DLC, appropriately titled *Mr. Torgue's Campaign of Carnage*. It begins the way Borderlands games typically do, with a story. But Torgue is

having exactly none of that. He interrupts the game's introductory mechanic by shouting, "BORING! You don't wanna hear about that, Vault Hunter! You wanna hear about loot! And pecs! And explosions! I'm Torgue and I am here to ask you one question, and one question only: EXPLOSIONS?"

At one point during *Campaign of Carnage*, players are tasked with finding a sponsor before they can enter a tournament to prove they are the most badass. This simple task is, of course, not very simple at all. Torgue explains, "I probably shoulda set you up with a sponsor beforehand but I am F*CKIN' DISORGANIZED AS SH*T and was busy suplexing a shark wearing a bolo tie when I should have been setting up sponsors. You may say, 'Who was wearing the bolo tie, you or the shark?' Answer: YES."

Mr. Torgue's Campaign of Carnage promises to be exactly what everyone wants: ridiculous fun that is so steeped in machismo that there is no option but to see its ridiculousness. When you begin the DLC, players are told, "By registering in the badass tournament, you legally forfeit your right to cry, eat tofu, or watch movies where people kiss in the rain and sh*t." These jokes, especially when voiced by Torgue, undermine the credibility of people who would actually say such things. The butt of the joke isn't men who eat tofu. The butt of the joke is hypermasculine Torgue *because* he says it with earnestness. The humor punches up, instead of down.

My favorite thing about Torgue is not that he's queer (another subversion of toxic masculinity), or that he's hilarious and silly, but that he's one of the main proponents for

respectful treatment of women. In *Campaign of Carnage*, Torgue warns the players, "Also, you should treat Moxxi nice! Nothing is more badass than treating a woman with respect!"

Never mind Torgue's outright affection for his grandmother, Grandma Flexington, another badass woman who raised a badass and compassionate child. When Torgue was a child, the only thing that stopped her from murdering a giant whale-squid creature was a tiny Torgue crying and begging her to exercise compassion for the creature. Oh, and Grandma Flexington is said to be a rank above the Vault Hunters when they enter the *Campaign of Carnage* tournament (remember that dude she gummed to death?). So even in old age, still seriously a granny not to mess with.

Between Brick, Torgue, and Salvador's one-liners, it's impossible not to love the way Borderlands mocks toxic masculinity at every turn, subverting what we've come to expect from our heroes in video games. As Salvador is wont to say, while massacring a bunch of bandits, "I am all that is man." Or as Salvador says, "I look like a fist with hair stapled to it." Which, you know, is also true.

Conclusion: Come at Me, Bro

It's funny to think you owe a lot of your success to one video game (or to one book, or to one film . . .). How much of where I've been and where I'm going is the result of weirdo happenstance? Too much, maybe, for comfort.

For *Dorkshelf*, I wrote an article talking about why I loved playing as Brick and Salvador in *Borderlands*. The article was born out of a conversation I had with my roommate: I realized that despite all of my self-esteem issues, especially in relation to appearance and my body, I always chose to play as macho man characters. As I wrote in "It's Good to Be Me: Choosing Characters and Classes in Video Games," "I realized it was because for me, these characters represented something I was striving to find in my own, personal life: to be able to unapologetically take up space. Brick and Salvador are not afraid to be seen and to be seen taking up space. They revel in their size and occupy it confidently (something I have never been able to do)."[51]

The things Salvador shouts in-game are magnificent exercises in self-confidence: "I am everything," "Oh, it's good to be me," and "I am very good at killing." Nothing about Salvador is invisible, and he never lets himself be insignificant. Playing as a character like that is very important to me. It's empowering to feed off that kind of confidence, even if it's just in a video game.

But, really, there's no such thing as "just a video game." No piece of culture or art is ever *just* a book, a movie, a song, a poem, because of the way it speaks to, represents, connects, empowers, undermines, supports, or emphasizes parts of our own humanity. Video games, like all other media, reflect what it means to be human, whether intentionally or not. As Katherine Isbister writes in her book *How Games Move Us: Emotion by Design*, "The game worlds [game designers] create may be imaginary, but the social dynamics are not."[52] The way we play and what we play cannot be removed from the very real social and human elements from which they were created.

And Borderlands fights to create a space that, as it reflects the dynamics we experience in the real world, can be fun, silly, thoughtful, and welcoming all at the same time. Borderlands knows it's ridiculous: it's ridiculousness is a badge of pride. It is a game wherein you are supposed to shoot *a lot of enemies and monsters*. And you're supposed to have fun while doing this. But the silly jokes and the over-the-top murder and *Mad Max* inspiration are a sly vehicle for compelling storytelling and progressive values. Pandora might be skag-eat-skag, but the

gaming industry doesn't have to be, and with more games like Borderlands, it may not be.

And people want more of this. *Borderlands 3* is already on its way. With Anthony Burch gone from Gearbox, the creative team behind *Borderlands 1* will be largely helming *Borderlands 3*, a game that I have many high hopes for — obviously. My biggest hope is that it will continue to prioritize creating a space where marginalized folks are welcome. While I fell in love with *Borderlands 1* for its world, its humor, and its fantastic gun play, it wasn't until *Borderlands 2* and *TPS* opened up its world — and its arms — to let people like me know we are welcomed, that this franchise became what it is to me.

It is a symbol of hope that attitudes can shift, that queer characters will be shown with nuance and in more than just stereotypical ways, that women can be great characters and can occupy various identities and personalities. This shift is already happening in games. *Dishonored 2* (2016) features three women at its core, who are all vastly different from each other, who are not all white, and who are explicitly queer. *Uncharted: The Lost Legacy* was announced in 2016 and stars two women, one of whom is Black. And *The Last of Us 2*, also announced in 2016, will feature Ellie, the teenager from the first game, as the main playable character. These major mainstream games are including and highlighting women as lead characters, which challenges the gendered toxicity in the video game industry. And it shows that the haven I found in Borderlands was not a one-off: this kind of inclusivity is rightfully here to stay. As a queer woman, this means a lot to me.

But also, acknowledging my privilege as a cis white able-bodied woman, I realize there's a lot more to be done to further inclusivity and let all marginalized folks know they're welcome and that they belong in this space. My hope is that *Borderlands 3* keeps trying and striving to be something better, and that it reaches further than the previous games in terms of representation. As Mikey Neumann says, "I firmly believe it is our job to represent people of all walks in media for no other reason than it is our moral duty to do so."[53] But it goes beyond moral duty. It makes for better, more subversive storytelling. Borderlands has never bothered to toe the line, and its storytelling has only ever benefited from this desire to be better, to be more, to push boundaries, and to see what it can say and what it can do.

I am so psyched to see where *Borderlands 3* will take me. Where it will take us.

*Endnotes

1 Kohler, Chris. "*Borderlands 2*: The Gateway Drug to Nerdy Addictions," *Wired*, 19 September 2012.

2 Bishop, Bryan. "Lucas and Spielberg on Storytelling in Games: 'It's Not Going to Be Shakespeare,'" *The Verge*, 13 June 2013.

3 Ebert, Roger. "Why Did the Chicken Cross the Genders?" RogerEbert.com, 27 November 2005.

4 Juul, Jesper. *Half-Real: Video Games between Real Rules and Fictional Worlds*. Cambridge: MIT Press: 2005.

5 "Parent Reviews for *Borderlands*," *Common Sense Media*, 2015.

6 Hutcheon, Linda. "Historiographic Metafiction: Parody and the Intertextuality of History," in *Intertextuality and Contemporary American Fiction*, edited by Patrick O'Donnell and Robert Con Davis, 3–32. Baltimore: Johns Hopkins University Press,1989.

7 Burch, Anthony. "Inside the Box: Designing Humor in *Borderlands 2*," Gearbox Software, 11 November 2013.

8 Burch, Anthony. "Inside the Box: Designing Humor in *Borderlands 2*," Gearbox Software, 11 November 2013.

9 Burch, Anthony. "Inside the Box: Designing Humor in *Borderlands 2*," Gearbox Software, 11 November 2013.

10 Tassi, Paul. "*Borderlands 2*'s Greatest Weapon: Humor," *Forbes*, 21 September 2012.

11 Zarzecki, Matthias. "What Makes Games Funny? A Look At Comedy and Humor in Video Games," *Tuts Plus*, 30 November 2015.

12 Rossignol, Jim. "Wot I Think: *Borderlands: The Pre-Sequel*," *Rock, Paper, Shotgun*, 21 October 2014.

13 Ellison, Cara, and Brendan Keogh. "The Joy of Virtual Violence," in *The State of Play: Creators and Critics on Video Games* edited by Daniel Goldberg and Linus Larsson. New York: Seven Stories Press, 2015.

14 Ellison, Cara, and Brendan Keogh. "The Joy of Virtual Violence," in *The State of Play: Creators and Critics on Video Games* edited by Daniel Goldberg and Linus Larsson. New York: Seven Stories Press, 2015.

15 Campbell, Joseph. *The Hero with a Thousand Faces*. Novato: New World Library, 2008.

16 Dinicola, Nick. "Of Assholes and Antiheroes: Morality in *Borderlands 2*," *Pop Matters*, 25 November 2012.

17 Williams, Walt. "We Are Not Heroes: Contextualizing Violence through Narrative," *GDC Vault*, 2013.

18 Williams, Walt. "We Are Not Heroes: Contextualizing Violence through Narrative," *GDC Vault*, 2013.

19 Hocking, Clint. "Ludonarrative Dissonance in *BioShock*," *Click Nothing*, 7 October 2007.

20 Burch, Anthony. "Inside the Box: Writing Handsome Jack." Gearbox Software, 23 September 2013.

21 Tsukayama, Hayley. "Forget Anti-Heroes. This Game Lets You Be the Villain," *Washington Post*, 25 August 2014.

22 Crecente, Brian. "Why *Borderlands: The Pre-Sequel* Is a Last-Gen Game Developed Outside of Gearbox," *Polygon*, 9 April 2014.

23 Wawro, Alex. "Writing *Deus Ex: Mankind Divided* to 'Hold a Mirror Up to the World,'" *Gamasutra*, 23 August 2016.

24 DePass, Tanya. "Thoughts on Game Criticism, Etc Because of *Deus Ex: Mankind Divided*," Medium.com/@Cypheroftyr, 24 August 2016.

25 Bishop, Bryan. "Lucas and Spielberg on Storytelling in Games: 'It's Not Going to Be Shakespeare,'" *The Verge*, 13 June 2013.

26 Burch, Anthony. "Inside the Box: Writing Handsome Jack," Gearbox Software, 23 September 2013.

27 Burch, Anthony. "Lots of Games Are Morally Bankrupt, We Get It," *Destructoid*, 19 March 2015.

28 Fussell, Sidney. "Video Games without People of Colour Are Not 'Neutral,'" *Boing Boing*, 26 June 2015.

29 Moosa, Tauriq. "Colorblind: On the Witcher 3, Rust, and Gaming's Race Problem," *Polygon*, 3 June 2015.

30 Burch, Anthony. "Inside the Box: Inclusivity," Gearbox Software, 26 August 2013.

31 Flanagan, Jack. "The Complete History of LGBT Video Game Characters," *The Daily Dot*, 16 May 2014.

32 Burch, Anthony. "Inside the Box: Inclusivity," Gearbox Software, 26 August 2013.

33 West, Nico. "*Borderlands* and Asexual Representation: How I Discovered My Sexuality While Playing a First-Person Shooter," *The Mary Sue*, 14 October 2015.

34 Neumann, Mikey. "A Is for (A)Sexual," *The Mary Sue*, 23 October 2015.

35 Henry, Elsa S. "Blind Lady Vs. *Borderlands 2*," *Feminist Sonar*, 2 December 2013.

36 Parlock, Joe. "Writing Characters, Not Symptoms: A Gamer with Autism Discusses What Our Hobby Gets Wrong," *Polygon*, 31 March 2015.

37 Vee, Ryoga. "Is Tiny Tina Racist?" YouTube.com/RyogaVee, 11 February 2013.

38 Amini, Tina. "Tiny Tina's Racism Reference in the New *Borderlands 2* DLC [Update]," *Kotaku*, 25 June 2013.

39 Fussell, Sidney. "Video Games without People of Colour Are Not 'Neutral,'" *Boing Boing*, 26 June 2015.

40 Jayanth, Meg. "10 Ways to Make Your Game More Diverse," *GDC Vault*, 2016.

41 Alexander, Leigh. "What Did They Do to You?: Our Women Heroes Problem," *Gamasutra*, 11 June 2014.

42 Hosking, Claire. "Bound Women: Why Games Are Better Without a Damsel to Save," *Polygon*, 14 October 2014.

43 Feminist Frequency, "All the Slender Ladies: Body Diversity in Video Games," YouTube.com/FeministFrequency, 1 September 2016.

44 Grayson, Nathan. "The Challenges of Letting You Be Fat in a Video Game," *Kotaku*, 22 September 2014.

45 Harper, Todd. "On Ellie," *Chaotic Blue*, 4 September 2014.

46 Gotzon, Aaron. "Down to Size: *Borderlands 2*'s Ellie and Body Image," *Ontological Geek*, 31 July 2013.

47 Lane, Rick. "The Art of Video Game Madness," *IGN*, 10 May 2013.

48 Newman, Jared. "7 Things I Learned after 15 Hours in *Borderlands 2*," *Time*, 19 September 2012.

49 DaRienzo, Gabby. "Death Positivity in Video Games," Medium.com/@Gabdar, 18 August 2015.

50 Velocci, Carli. *"Tales from the Borderlands* Knows the True Meaning of Masculinity," Playboy.com, 9 January 2016.

51 Tremblay, Kaitlin. "It's Good to Be Me: Choosing Characters and Classes in Video Games," *Dorkshelf*, 19 May 2015.

52 Isbister, Katherine. *How Games Move Us: Emotion by Design*. Cambridge: MIT Press: 2016.

53 Neumann, Mikey. "A Is for (A)Sexual," *The Mary Sue*, 23 October 2015.

Acknowledgments

First off, thanks to my incredible editors at ECW Press, Jen and Crissy, who took a chance on this book about a video game ostensibly about dumb jokes and dancing robots and letting me prove that it is so much more than that. Jen and Crissy's editorial feedback, patience, and willingness to sit through *Borderlands 2* for this book was wonderful, and this book wouldn't be what it is without their keen insights.

Lots of thanks also to the amazing folks at Dames Making Games, who helped me feel accepted and to find my place in video games. Thanks to all the women in video games who inspire me constantly and encourage me to be my best: Leisha Riddel, Gabby DaRienzo, Jen Costa, Arielle Grimes, Sophia Park, Kim Koronya, and all the other incredible people I've met through DMG and Gamma Space, especially to Jennie and Henry Faber for always being in my corner. And to everyone else in my games community, fighting the good fight and making games such a wonderful place to be. My friends, John R., Travis Taylor, Braydon Beaulieu, Lindsay Baker, Mic

Fok, and Dominik Parisien, who put up with me incessantly talking about Borderlands after (and before) too much beer and letting me work out ideas (and for hanging out with me when I needed a pick me up). Thanks to Soha E. for connecting me with Anthony Burch to let me awkwardly geek out about this book (and to Anthony!). And to Manveer Heir for being the Wrex to my Grunt. A special thanks to Jake Babad for being a good friend and helping me navigate through so much of this.

Of course, many, many thanks to my mom and stepdad, Rob, and my brothers, Brian, Eric, Matt, and Jere, my sister-in-law, Felicia, and my grandma for being constantly supportive of me, even if thinking I'm the biggest nerd ever. Thanks, Mom, for always supporting my ambitions and making me realize I'm the only one ever stopping me from achieving exactly what I want. And for showing me how to be the stubborn, unstoppable force that I am.

Thanks so much to Kelsi Morris, the only person with whom I can have a full conversation solely using quotes from Borderlands. And finally, to Jonathan Levstein, for being my biggest fan, my unrelenting supporter when I needed lifting up, and a constant source of love, jokes, and companionship. For knowing me completely, and for showing me the strength in my own voice and skills. Kelsi and Jon, Borderlands has never been better than when I got to play it and share it with both of you, and you've both taught me that playing co-op isn't the worst (and can actually be the best . . . with the right people).

Kaitlin Tremblay is a writer, independent game developer, and narrative designer in video games. She is the co-editor of the speculative fiction anthology *Those Who Make Us: Canadian Creature, Myth, and Monster Stories* (Exile Editions, 2016) and has written about video games for *Playboy*, *Vice*, and the *Mary Sue*. She is the lead writer on the death positive video game *A Mortician's Tale* (Laundry Bear, 2017). She is a narrative design mentor in video games and can always be found ranting about video games and storytelling on Twitter at @kait_zilla. Kaitlin lives in Toronto.